MOUNT RAINIER

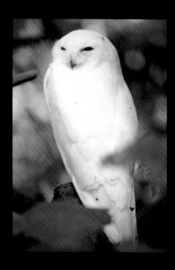

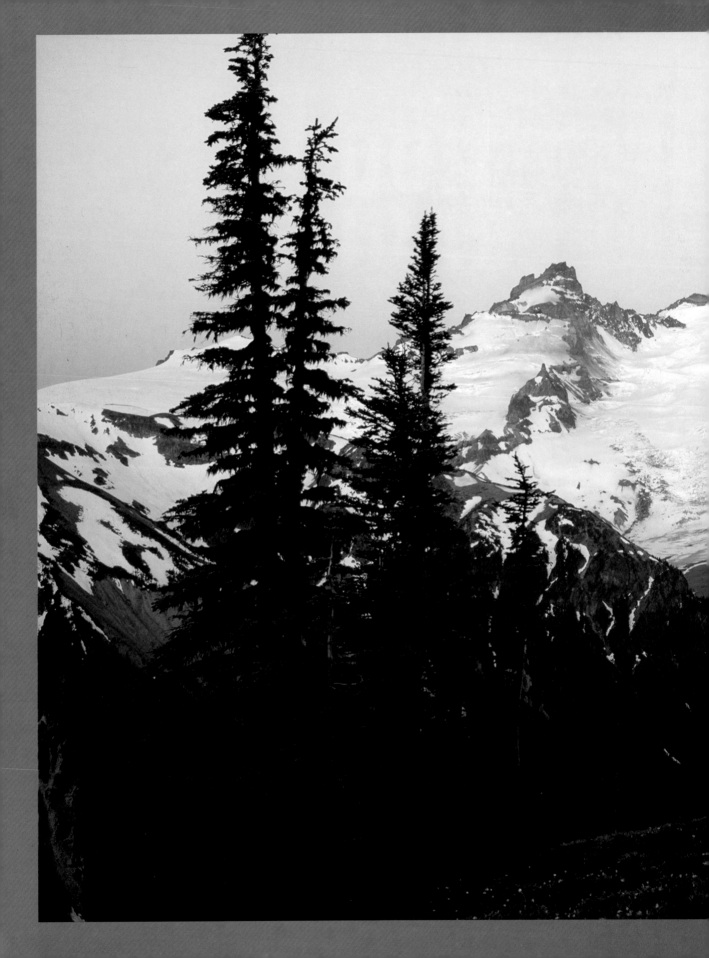

Photography by James Martin
Text by John Harlin III

MOUNT RAINIER

NOTES AND
IMAGES FROM
OUR ICONIC
MOUNTAIN

THE MOUNTAINEERS BOOKS

THE MOUNTAINEERS BOOKS
is the nonprofit publishing arm of The Mountaineers,
an organization founded in 1906 and dedicated to the exploration,
preservation, and enjoyment of outdoor and wilderness areas.

1001 SW Klickitat Way, Suite 201, Seattle, WA 98134

Distributed in the United Kingdom by Cordee, www.cordee.co.uk

Manufactured in China

Copy Editor: Don Graydon
Book Design: Karen Schober
Cartographer: Linda Feltner
Cover photograph: *Avalanche lilies appear just as the snow melts. Here they carpet the open space on the
south side of Plummer Peak.*
Photo captions: Page 1: *Snowy owl.* Preceding page: *Across the White River Canyon the glaciers of
Mount Rainier glow at first light.* Right: *Red-tailed hawk*

Library of Congress Cataloging-in-Publication Data

Harlin, John, 1958–
 Mount Rainier : notes & images from our iconic mountain / photography
by James Martin ; text by John Harlin III.
 p. cm.
 Originally published: Seattle : Sasquatch Books, c2001.
 Includes bibliographical references and index.
 ISBN 978-1-59485-726-3 (pbk : alk. paper) — ISBN 978-1-59485-727-0
(ebook : alk. paper)
 1. Rainier, Mount (Wash.)—Pictorial works. 2. Rainier, Mount
(Wash.)—Description and travel. 3. Harlin, John,
1958—Travel—Washington (State)—Rainier, Mount. 4.
Mountaineering—Washington (State)—Rainier, Mount. I. Martin, James,
1950- II. Title.
 F897.R2.H36 2012
 979.7'78—dc23
 2012011111

ISBN (paperback): 978-1-59485-726-3
ISBN (ebook): 978-1-59485-727-0

For Peter Potterfield,
who is always ready to lace them up.
—J. M.

To my mother, Marilyn Miler Harlin,
who first inspired me to love the natural world, and to
my daughter, Siena Hammond Harlin,
whom I love as the world itself.
—J. H.

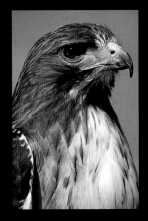

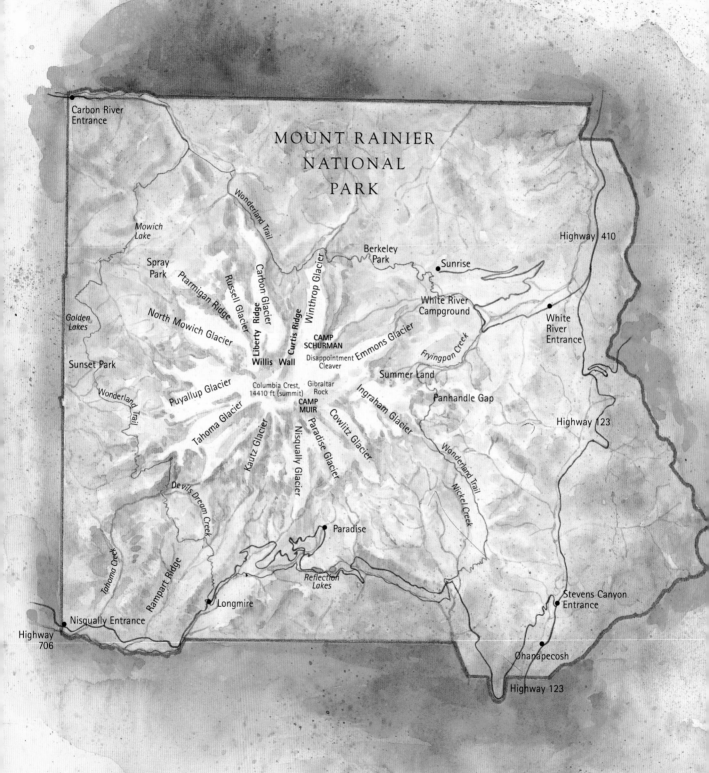

MOUNT RAINIER
NATIONAL
PARK

Carbon River
Entrance

Mowich
Lake

Wonderland Trail

Berkeley
Park

Highway 410

Spray
Park

Sunrise

Golden
Lakes

Ptarmigan Ridge

Russell Glacier

Carbon Glacier

Winthrop Glacier

White River
Campground

North Mowich Glacier

Liberty Ridge

Curtis Ridge

CAMP
SCHURMAN

Emmons Glacier

White
River
Entrance

Sunset Park

Willis Wall

Disappointment
Cleaver

Fryingpan Creek

Wonderland Trail

Puyallup Glacier

Columbia Crest,
14410 ft (summit)

Gibraltar
Rock

Summer Land

Panhandle Gap

Highway 123

Tahoma Glacier

CAMP
MUIR

Ingraham Glacier

Kautz Glacier

Paradise Glacier

Cowlitz Glacier

Nisqually Glacier

Wonderland Trail

Nickel Creek

Devils Dream Creek

Paradise

Tahoma Creek

Rampart Ridge

Reflection
Lakes

Stevens Canyon
Entrance

Nisqually Entrance

Longmire

Highway
706

Øhanapecosh

Highway 123

contents

Introduction: Personal Connections

"You can only wonder —

that something so large

can rise so lonely."

Introduction: Personal Connections

Windshield wipers swish-swashed and my three-year-old daughter sleep-talked as we drove toward Paradise. Nothing but moss-draped trees pierced today's dank skyline, but I knew that entire tourism industries had been built on what we ought to be witnessing: the Lower 48's most spectacularly glaciated peak bursting from a spectacle of wildflowers. They named our road's end "Paradise" because that's what it feels like on a sunny day.

Today was different. The fact that a mountain lurked somewhere up there in the clouds could only be deduced by the grade of the road, and Daddy worried about how he was going to entertain his little girl on their camping trip. Sleeping Siena and I had the pavement pretty much to ourselves until I braked beside an idling car. And then I saw the bear. Small, black, but right at the edge of the pavement. In seconds Siena had scrambled to my lap, where she raptly observed the masticating creature just thirty feet away. This beast of lore had been as mythical and fascinating to her as a princess in a fairy tale, but now by some magical process a genuine bruin had climbed off the page. Rain flowed through our open window even as Siena insisted we keep our eyes peeled thirty minutes after the blackie had faded into the forest. Just in case.

During three days of camping and hiking we never did see Mount Rainier, but I'm certain the hairy roadside creature made a greater impression on

my daughter than would a month of blue-sky panoramas and postcard views of Rainier's gigantic dome. This three-year-old's perspective opened my forty-three-year-old eyes to the fact that Rainier is bigger than I'd imagined it, even though I'd climbed it twice. Contrary to my prejudice, this mountain doesn't materialize only up at tree-line altitudes where life fades to the dead realm of rock and ice. Instead, Rainier is a complex of personalities where lowland forests at 3,000 feet are as much a part of her character as are volcanic vents and freezing winds at 14,000 feet.

Rainier long has been an icon, maybe *the* icon, of the Pacific Northwest. Near sea level on Puget Sound, where legions of bipedal worker ants toil their daylight hours away, those lucky enough to get a window cubicle stare wistfully to the southeast. They know the drizzle will eventually ease, the gray pall will lift, and they'll shout jubilantly, "The Mountain is out!" All will stop to stare at the brooding hulk just fifty miles inland, and they'll remember why they or their ancestors had moved to this moss-clogged land. Worker productivity will plummet in inverse proportion to soaring spirits, until the inevitable curtain of clouds draws an end to the show and wistful eyes drift back to flickering monitors.

These grownups don't hold in their hearts a child's vision of bears. Instead theirs is the classic image of a towering mountain that dominates its landscape. I can't say that I blame them, as it's so much harder to know those intimate details than the great spectacle of a huge peak so sublime that a mere glimpse stops you dead in your tracks. From a distance, you can only wonder that something so large can rise so lonely. Mountains, we've come to believe, enjoy the company of other mountains. Just think of the Sierra, the Rockies, the Whites, the Alps, the Himalaya. Rainier isn't like them. Rainier is a range unto itself. In Washington it is simply "the Mountain."

As a youth I spent a half-dozen years alongside Puget Sound and developed a taste for climbing and skiing volcanoes. By the time I was fourteen I'd worked my way up and down Mount St. Helens (before it blew its top), Mount Hood, and Mount Baker. But Rainier's 14,410 feet topped the highest of these by a good 3,000, and the only time I'd readied myself to climb her, a raging storm blew through. When the storm ended, we learned it had killed two climbers. My family moved to the East Coast the following year, and Rainier's great rounded bulk faded from the forefront of my thoughts. But the mountain lay merely dormant in me, a hazy mental blend of awesome beauty, emblem of my beloved Northwest, and unfinished personal business.

On the twentieth anniversary of watching Rainier meld into the skyline

Right: *False hellbore in the park's lowlands.*

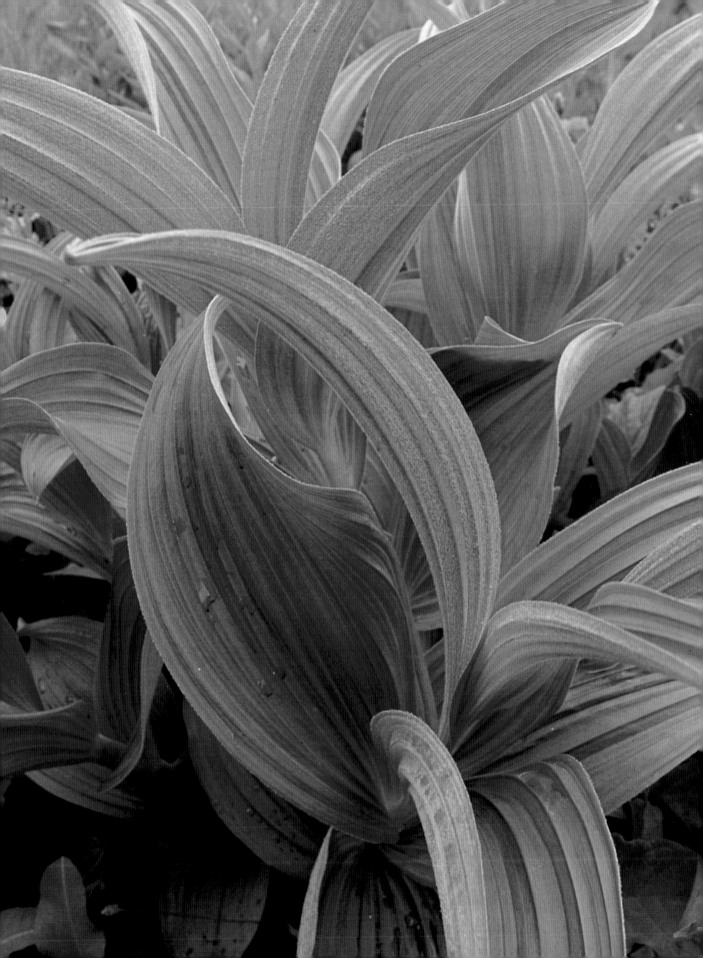

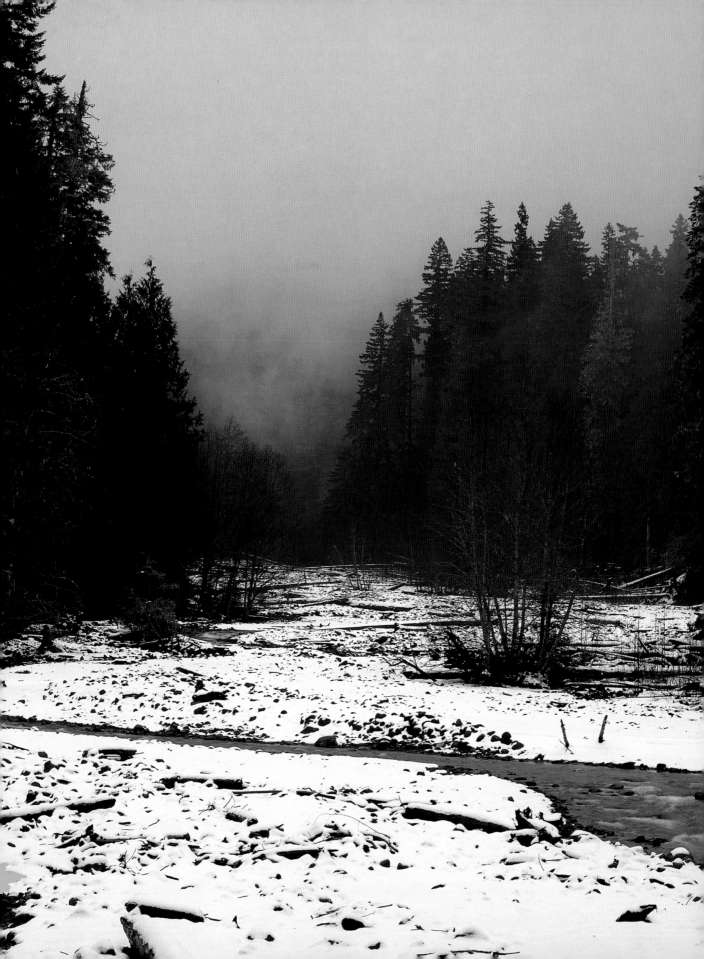

from the rear window of my mother's Dodge Dart, I observed it emerging through the windshield of my wife's Isuzu Trooper. I'd finally returned to the Pacific Northwest for good, and my top outdoor priority was to climb and ski Rainier. It was a brilliant August morning in 1991 when my ski buddy Craig and I awoke to a mountain bathed in alpenglow; huge as it was, in the clearness of dawn it tempted like a heaven-size scoop of cherry sherbet. A few hours later we stood breathless on the cold, bright summit.

Below us unfolded every splendor of the Pacific Northwest. Freshly returned to this great land, I savored all 360 degrees of panorama. To the northwest, island-studded waters and concrete jungles sprawled across the Puget Sound basin; stretching south to north, snowy volcanoes glinted like a string of Cascade pearls; due west stood the layered peaks of the Olympic Mountains, our nation's first bulwark against Pacific frontal systems; eastward, vast plains fanned across dry rain-shadows. Such a magnificence of diversity, a continent of wonders revealed in a single pirouette.

Mistress of it all was the sleeping giant under my skis. Craig and I soon pointed the boards downhill and carved an eternity of turns until summer slush melted into verdant meadow. It had been a perfect day, the fulfillment of a boyhood dream, and the first of a new string of personal adventures on the Mountain.

I'm not sure how photographer Jim Martin learned of my fondness for Rainier; perhaps this affection is simply assumed among Northwest mountaineers. In any case, when he invited me to write a few words to accompany his photos, my answer came sure and swift. What mountaineer, having feasted at Paradise, could resist telling stories to accompany such splendid images as those contained on these pages? I knew that Jim's work would capture the Northwest's grand symbol like a perfect reflection on a dawn-smooth pond. I could only hope that my prose might bring the landscape to further life by pulling you, dear reader, into the picture, with me serving as your eager proxy. Together we'll mop sweat from our brows as we crest ridges, then zip jackets against the nippy breezes that cut implicitly through these pictures. We'll ruffle the photographer's pond and dunk ourselves in the mountain behind the reflection, understanding that pretty pictures are fairy tales and that reality is bears in the grass and rain on the face.

Go ahead, revel in Jim's idyllic imagery. He worked hard to make things perfectly so. Then go out and put dirt in your lugs, snow in your mitts, and a crevasse at the business end of your personal nervous system. The Mountain awaits.

Left: *Tahoma Creek twists lazily through low forest near the park border.*

Following page: *The open crevasses visible from Sunrise Point indicate that climbers should take care on the Emmons Glacier route up the mountain.*

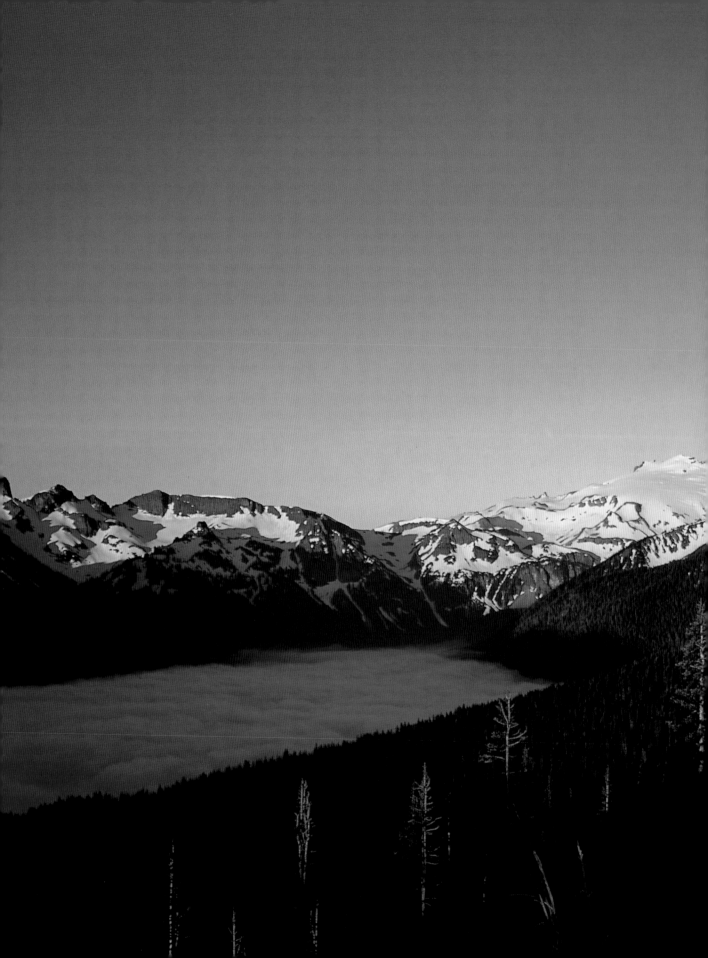

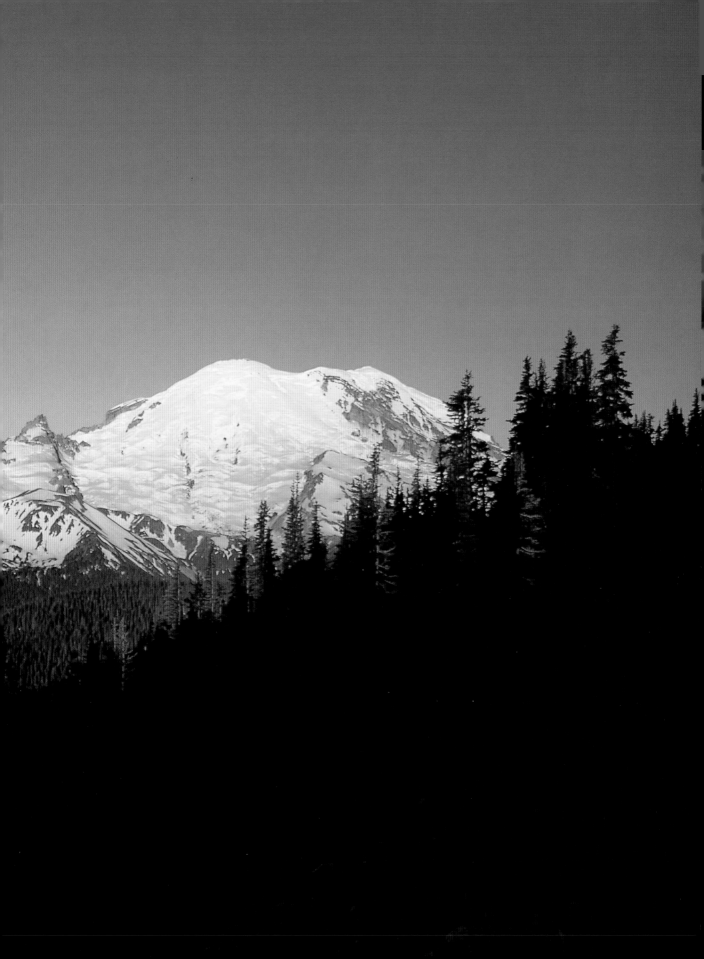

Liberty Ridge

"Storm crystals

drove into my eyes so hard

it hurt even to squint."

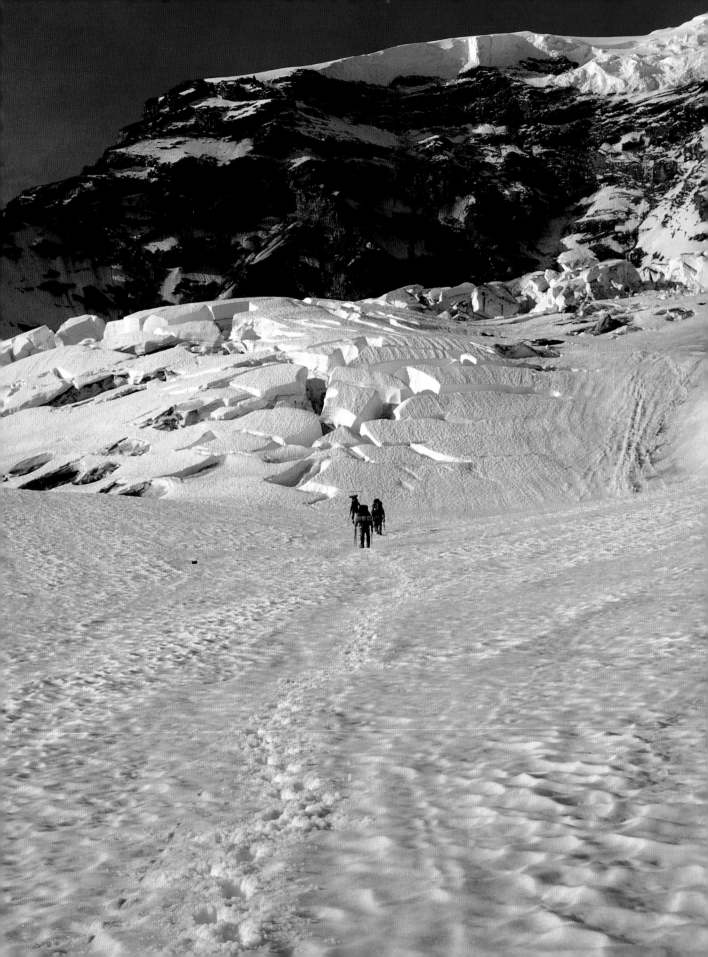

liberty ridge

The trouble with glaciers is that they want to eat you. Late in the summer it's usually easy enough to avoid the digestive tract of Rainier's ice dragons because their mouthparts—crevasses—lie exposed to the world. All a climber has to do is step up to a crunchy bare-ice lip, toss a taunt down its gullet, and walk around the gaping orifice. The hungry, unsatisfied glacier creeps downward, hoping for better luck when autumn snow blankets the surface and hides what lies beneath.

In early August, as Nicho Mailaender and I hiked toward the Liberty Ridge on Rainier's north face, we found the Carbon Glacier at 8,000 feet so

diced with crevasses that in places there was no way to stay above them. Instead we cramponed down sharp-edged mandibles, balanced over piles of massive broken ice teeth, teetered on ramp-like tongues. But glaciers are slow-moving beasts, and that dawn we outmaneuvered the Carbon's efforts and left it to dine upon less agile victims, like rocks, of which it had a steady diet forever tumbling from the wall above.

That evening, at 14,000 feet, we encountered a younger, stealthier animal, smoothly complexioned and veiled with new-fallen snow. We crested Liberty Cap, the summit of our ridge, with a couple hours of daylight to spare. After spending the day on 40- to 60-degree terrain, the nearly flat crossing to the Emmons Glacier appeared a simple hike.

Nicho was leading when he disappeared. I didn't notice his vanishing act so much as the yank of the rope that jerked me off my feet and across the snowfield. In a lurch of fear, I dropped onto my ice axe and stopped the slide, though not my pounding heart. With a tenuous grip on the frozen turf, I pulled my second axe out of its holster and pounded it shaft-deep into the snow. In what seemed mere moments to me and likely an eternity to Nicho, I had both tools and a snow picket buried and anchoring the rope. Freed from the burden of holding my fallen partner, I walked carefully toward a hole in the snow, the only clue that underneath lay the unfathomably deep gullet of this hungry ice dragon. I was less anxious about getting Nicho out of the pit, which we'd surely accomplish somehow, than about the waning day. The sun had nearly crossed the Olympics on the other side of Puget Sound. Alpenglow was beginning to kiss our own suddenly monstrous mountain, and the temperature had already plunged well below freezing. This wasn't where I wanted to spend the night.

⌒

In climber's parlance, the Liberty Ridge is perhaps the most "classic" route on Rainier. The designation comes not so much from its inclusion in Allen Steck and Steve Roper's popular book *Fifty Classic Climbs of North America*, but because of the traits that merited its inclusion in the first place. The classics are the routes we dream of, the ones that symbolize everything we like best about mountains—things like elegance, quality of climbing, and a fascinating history.

The Liberty Ridge has all three traits in abundance—elegance, quality, and history—but it excels above all in the first. It's a rare and precious gift

Right: *A golden eagle, one of the largest birds in the United States.*

Following page: *The summit of Little Tahoma affords a commanding view of the terminus of Emmons Glacier and Sunrise Ridge.*

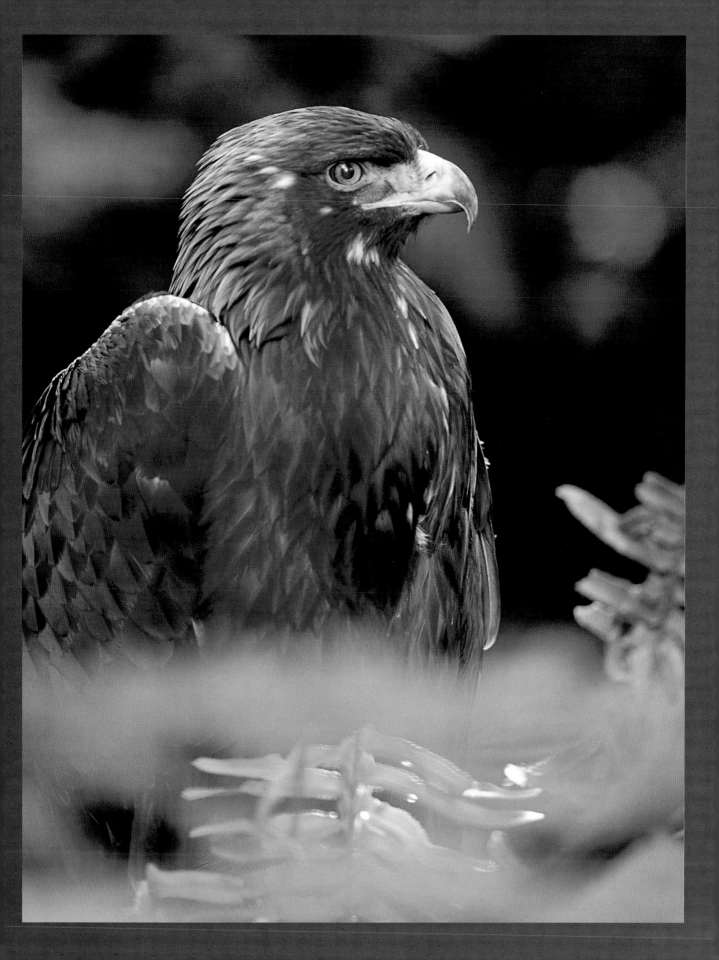

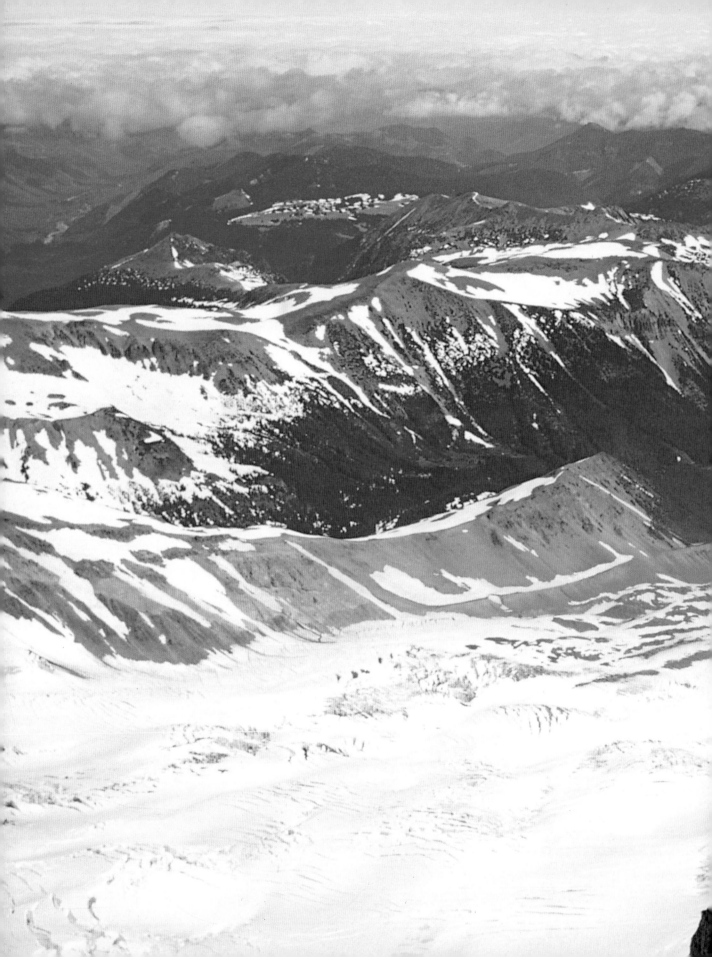

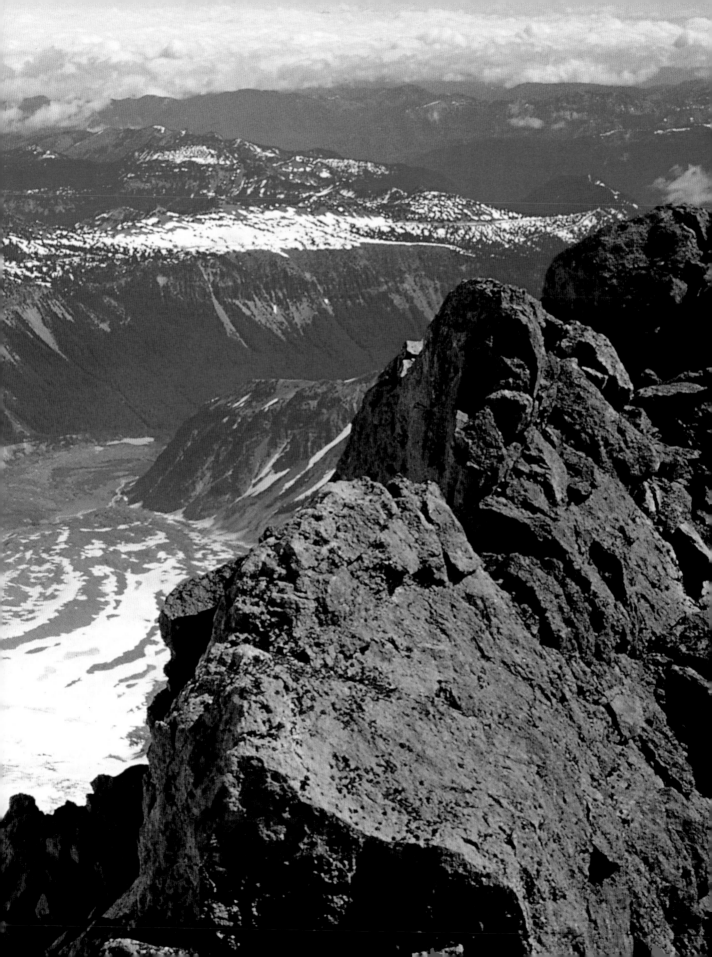

to climbers when a mountain presents a climbable feature that stands as strikingly as this ridge, a perfect cleaver splitting the most fearsome wall on the most powerful mountain in the contiguous United States. In 1935 the first ascent party on the Liberty Ridge bivouacked at Thumb Rock, the only spot on the mile-long ridge that offers a reasonable hope of hacking a flat ledge in the snow. After finishing a tin of food, they tossed the empty into the abyss on the far side of the ridge and listened. They heard no sound, they claimed, until five minutes had passed and the clatter of tin on rock finally reached their ears.

To say they heard no sound is to imply the silence one would expect from high, still places. But stillness is as rare as a benevolent dragon on Rainier's north wall. This huge expanse is capped by glaciers some three hundred feet thick that creep over the void until they can hang no longer. Then at random, nerve-wracking intervals, freighter-loads of ice split off. Climbers glance left and right and once more thank the Mountain for providing a

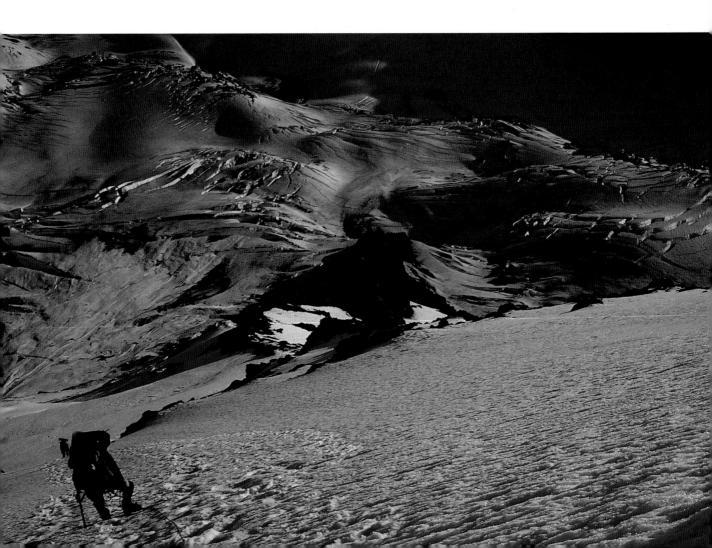

safe avalanche-splitting cleaver from which they can enjoy the north-face spectacle instead of being destroyed by it.

It's typical of northern hemisphere mountains to cloak their dominant feature in north-facing shadows. That's because big mountains are carved by glaciers—if not now, then during colder climes of old. On most mountains you can deduce this effect from the fossil evidence of glaciers past. Each carved face of the mountain might rise from a long-abandoned cirque. This dished-out region is the former headwater, so to speak, of a glacial river, and at this source the ice nibbled constantly into its mother mountain. As a rule, the northern faces have been eaten-at the hardest and longest, which results in the steepest and tallest cliffs. Certainly that's the case on Mount Rainier, even if underlying volcanic processes also gave it shape.

The first time I hiked around to its north side, the Mountain lashed me. Fresh out of college, where I'd spent a few seasons climbing in the mild Sierra, I walked toward the Liberty Ridge at night with a friend from California. It had been a fine summer day in 1978, but for some unremembered reason we made the ten-mile approach entirely in the dark. I do recall the dim and sinister blackness towering above us, drapery drawn against the stars. And I remember that the closer we came to our bivouac, the stronger the winds blew. They kept building during the few hours we spent horizontal. That dawn, as we crested the Carbon Glacier's lateral moraine and stared across a miserable tangle of crevasses, storm crystals drove into my eyes so hard it hurt even to squint. I had forgotten my goggles, and now I was blinded by the wind's fury. Rising through the rage was the hazy outline of the Liberty Ridge, the dream that had pulled us a thousand miles from our homes. We turned our backs to the wind and it blew us home.

Left: *A roped climber trudges up the final slope of Liberty Ridge.*

Following page: *For a few weeks each year the mountain meadows come alive with color.*

Two decades later Nicho and I stepped onto the same wretched glacier, but in the calm of a perfect August dawn. We'd been warned away by rangers telling us that few people attempt the route this late in the year, when the Carbon Glacier has melted into a labyrinth of overlapping crevasses. The most recent party to attempt the route had been defeated by this crossing well before setting foot on the ridge itself. But Nicho was visiting from Germany and this was our day to seize. We wandered through the maze doing pretty well until we approached the toe of the Liberty Ridge, where intersecting moats cleaved the ice. Bedecked in modern gear—two ice axes

each, plus sharp crampons with points projecting out the front—we were able to slither through a hole between a giant ice block and the vertical ice wall itself. We gloated as we stepped onto the ridge, for try as it might to block us, the Carbon had only served to entertain.

The smugness ended as we came to know the steep rubble that's euphemistically called "rock" by volcano climbers. Dee Molenaar, a leading Mount Rainier activist of the mid-twentieth century and author of *The Challenge of Rainier*, described the north face as rising 4,000 feet "in a long sweep of crumbling, downward sloping ledges of lava, ash, consolidated breccias and mudflows, and dirty, rock-impregnated ice." Occasional baseball-size rocks clattered past as we wove our way over short rock bands and along endless ledges filled with gravel-like scree. At long last we left the decomposing stone behind and moved more confidently up a smooth ice field where spikes and picks held us to the mountain like cats on a tree. Once you have the knack for such movement, the only difficulty is maintaining the endless pace, which wears heavily on the calf muscles.

The first chance for a good rest came at Thumb Rock, that spectacular bivouac where the first ascent party tossed their can. We munched our gorp and stared awestruck at the north face's most intimidating section, the notorious Willis Wall. Stones clattered endlessly down its face, and once a boxcar-size ice block peeled off the top, ripping downward in a 4,000-foot tornado of billowing ice dust. The fact that climbers ascend the Willis Wall seemed incomprehensible to us—a game more akin to Russian roulette than the vertical dance we cherished.

We weren't the first climbers to be intimidated by north walls. Because they're typically the biggest, steepest, and coldest faces on a mountain, they're usually the most difficult to climb. During the early twentieth century, north faces became the last bastions against increasingly talented climbers. In the 1920s and '30s top European mountaineers, who had long since overcome the easier defenses of the Alps, were turning their attention to the shadowed walls. The Matterhorn's north face succumbed in 1931. The biggest and last of them all, the 6,000-foot north face of Switzerland's Eiger, wasn't climbed until 1938, and that was after it had already become known as the *Mordwand*, or Death Wall, for the fate of the many mountaineers who had died attempting it. My own father, a great fan of north faces, died there in 1966 in a fall of 4,000 vertical feet—the same distance traveled by the huge icefall Nicho and I had just witnessed on the Willis Wall.

Right: *Two glaciers grind a fin of rock, sanding off enough material to create a medial moraine, seen here as a dark stripe in the ice.*

Following page: *In a heavy snow year the tarns at Chinook Pass don't melt out completely.*

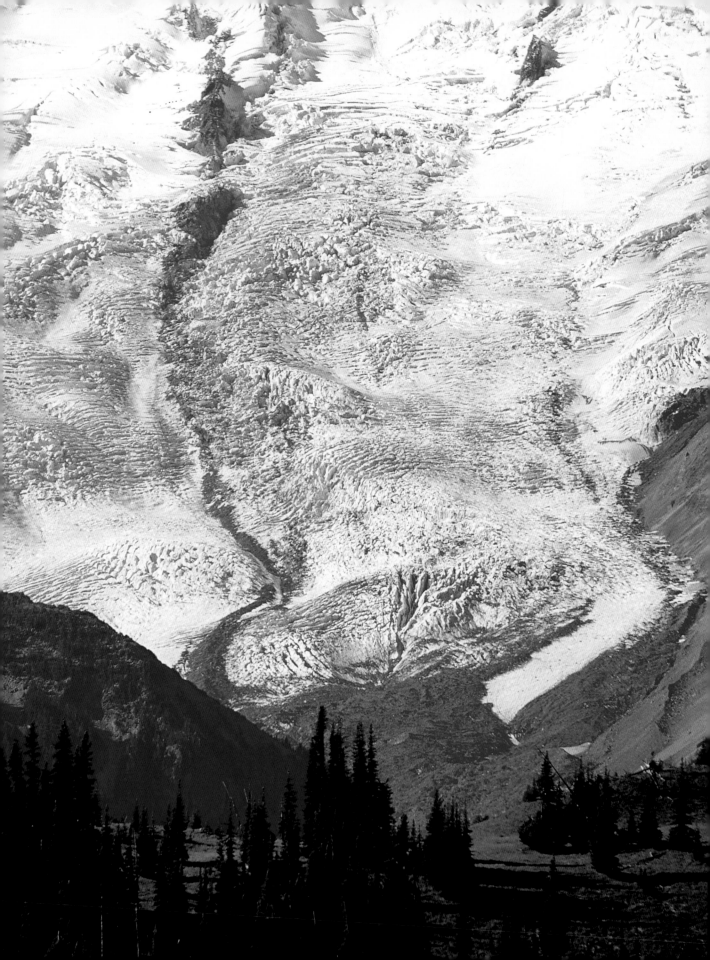

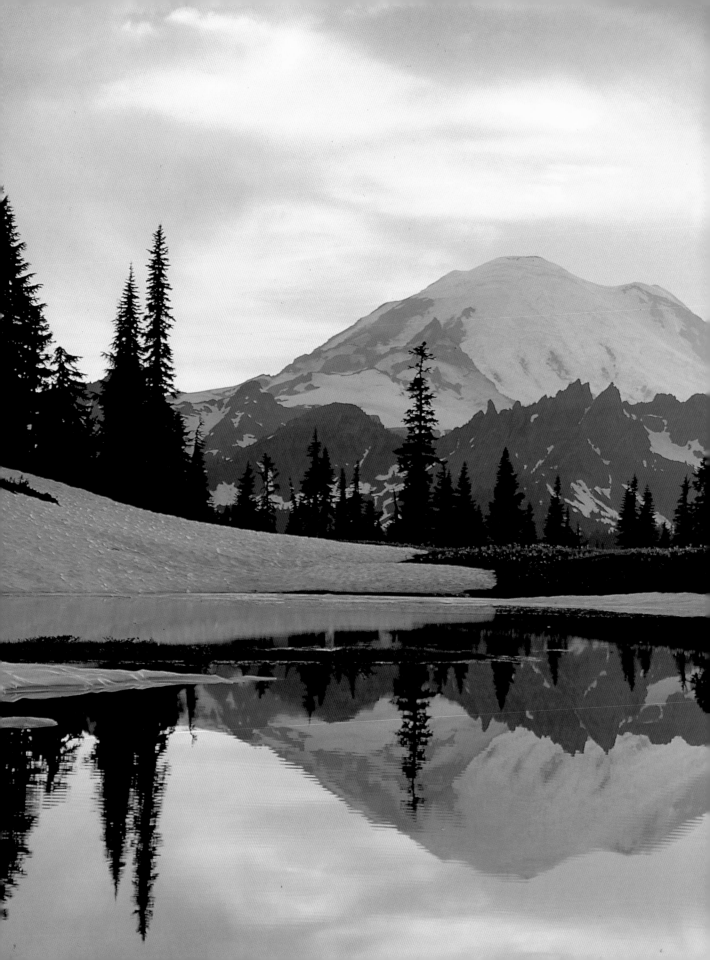

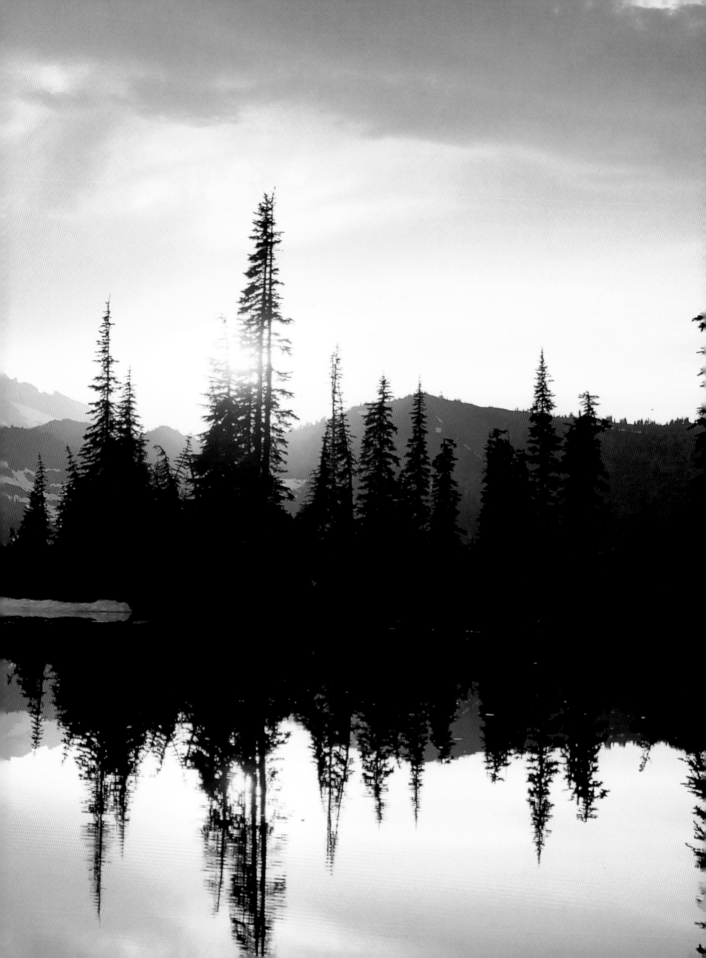

Like its Alpine counterparts, Rainier's frightening north side was ignored by early climbers, but people had long had their eyes on the summit. Native Americans, who called the peak Tahoma, meaning "snowy mountain," described a fiery lake on the summit, though there's no clear indication that Indians ever reached that point. The first European to visit the region was Captain George Vancouver in 1792. He spied the mountain from his ship in Puget Sound and promptly named it for his English friend Commander Peter Rainier. The fur trade brought a few whites into the Northwest in the early 1800s, but it was the wagon trails of the 1840s that permitted settlers to roll in en masse.

In 1852 a couple of surveyors and their Indian guide may have summitted, but the first fully documented attempt came in 1857, when Lieutenant August Valentine Kautz, followed by Private Nicholas Dogue and Dr. Robert Orr Craig, reached the plateau just four hundred feet shy of the true summit. They had been fast that day, climbing 8,000 vertical feet in ten hours, but weariness and the lateness of the day made them turn back for their camp down in the trees. Their amazing pace, speedy even for today's strongest climbers, is all the more phenomenal in that big glaciers and high altitude were terra incognito in those days. Climbing as a sport hadn't yet been invented in America, and those few who ventured high had no knowledge of the brutal world of snow, rock, and gaping-holed ice. More than the mountain itself, these explorers were battling the common belief that climbing Rainier was a physical impossibility.

Thirteen years later General Hazard Stevens and Philemon Beecher Van Trump became the first to definitively reach the summit. Stevens' and Van Trump's Indian guide, Sluiskin, tried his utmost to dissuade them from venturing onto the glaciers, believing that even an attempt was suicidal. When his exhortations failed, Sluiskin asked the whites for a letter absolving him from blame. Stevens and Van Trump started out with another companion, Edmund T. Coleman, who actually had real mountaineering experience from Europe and was a member of Britain's elite Alpine Club. Ironically, Coleman had to drop out from the attempt because he believed so much equipment was necessary that the weight of his pack slowed him down and he couldn't keep pace with his naïve (and admittedly much younger) companions.

Right: *Carbon Glacier and Liberty Ridge loom above a climber's camp on lower Curtis Ridge.*

Following page: *Thickets of thorny devil's club block passage in the wet areas of deep forest.*

Fortunately, Stevens and Van Trump had learned a few things from Coleman and brought with them a rope, crude crampons, and an ice axe, all of which they put to use while ascending steep snow and ice on what is now called the Gibraltar Ledges route. At one point they even lassoed a tall spike of snow, and on this lasso they pulled themselves upward. In other

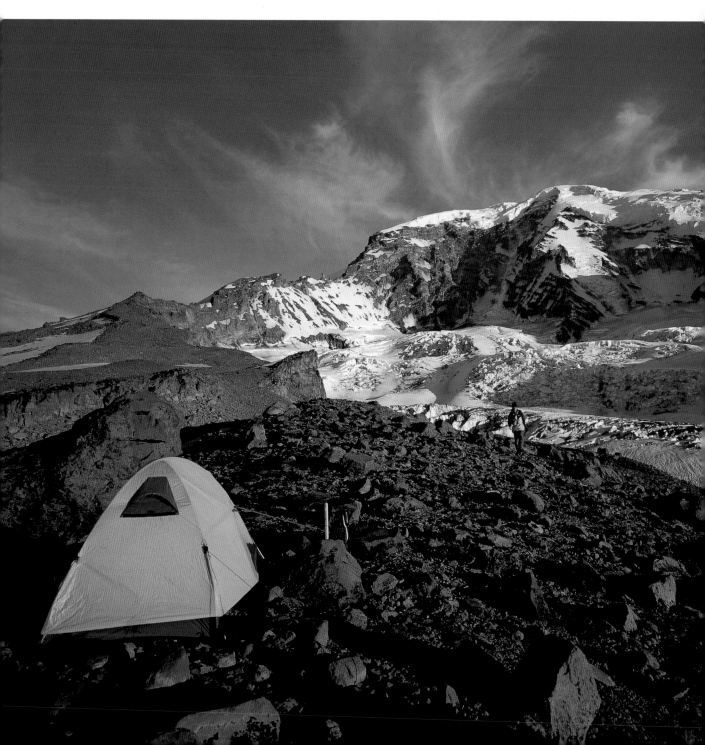

places they chopped steps with their ice axes, surely one of the earliest times this mountaineering technique was performed in North America.

Almost a dozen hours after leaving their timberline camp 8,000 feet below, the climbers reached a point just below the summit. Realizing they could never make it back down that night, they were overjoyed to discover a volcanic steam vent in whose cavern they could shelter themselves until dawn. It proved a miserable night spent roasting one side against the steam while the other side froze, then flip-flopping the indignities. But it was better than no heat at all on a wind-blasted 14,000-foot ice summit. While the next day dawned bleak inside a frigid cloud, the climbers forced themselves to explore the summit briefly and place a commemorative brass plaque on the high point before heading downward at maximum speed. When eventually they reached camp, Sluiskin examined them carefully for some time before accepting that they weren't spirits, but had indeed survived.

The next ascent, accomplished in a single-day round-trip from timberline (and including firewood in the summit pack!), took place just two

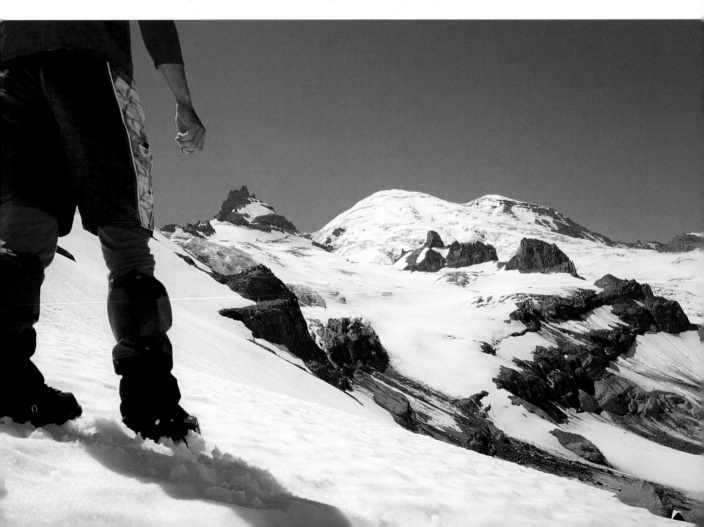

months later. By the turn of the century, well over a hundred people had reached the top, including one 1897 party from Oregon's Mazamas climbing club that brought two hundred people to base camp at Paradise, carrying four tons of equipment and setting up forty-five tents. A week later, fifty-eight climbers reached the summit during a single day, and eight voluntarily spent the night on top, a common practice at the time.

When General Stevens returned for his second ascent, in 1905, he was astounded to learn that during the intervening years some thirty thousand people had reached the place called Camp of the Clouds (just above today's Paradise Inn). He wrote that what had been an arduous bushwhack for him forty-five years earlier leading to a place of "vast solitude" now was served by a "magnificent road." At least on the south side, the era of wilderness was over. But the north side, not served as closely by roads, retained its isolation.

Nicho and I felt utterly alone as we cramponed endlessly upward after lunch at Thumb Rock. At one spot, to rest my aching calves, I scrabbled to a knife-edged rib of what looked like rock. But it proved so unconsolidated that I worried about the whole thing crumbling out from under me, and I turned back to the brutal test of calf endurance. Clouds roiled through as we moved up steep ice on the final few hundred feet, but somehow I could sense—perhaps from the sound, perhaps just from an intuition of emptiness—that we were climbing at the very lip of the glaciers that overhung the dizzying void of the Willis Wall. And then we were up, standing on a house-size point of snow that tops the Liberty Crest, the sub-summit three hundred feet and a half mile west of Rainier's ultimate point.

A few minutes later the rope yanked me off my feet and Nicho found himself swinging in space inside the crevasse.

A muffled call came from below.

"Slack!" That means *feed me rope*, and, based on the tone of voice, *do it now!*

I ran back to where I'd anchored the rope and struggled with the knot. I should have used a slipknot but I hadn't, and it took agonized minutes to loosen the cord and feed slack through. Eventually the tension eased and I could tell that Nicho was no longer dangling. I kept feeding rope into the pit. Finally a head stuck through, then a figure crawled out—on the far side. Nicho had pendulumed to a snow ledge thirty feet down in the crevasse (of

Left: A climber traverses Fryingpan Glacier en route to Little Tahoma.

Following page: *Sunset on a hazy summer day paints the slopes above Saint Andrew's Lake in pastels.*

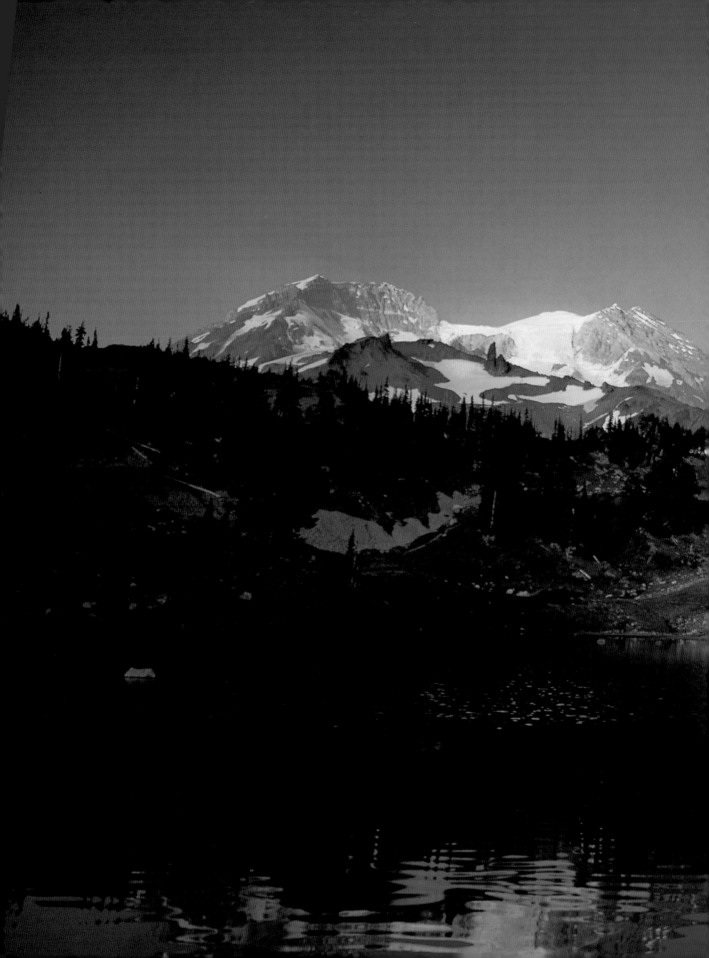

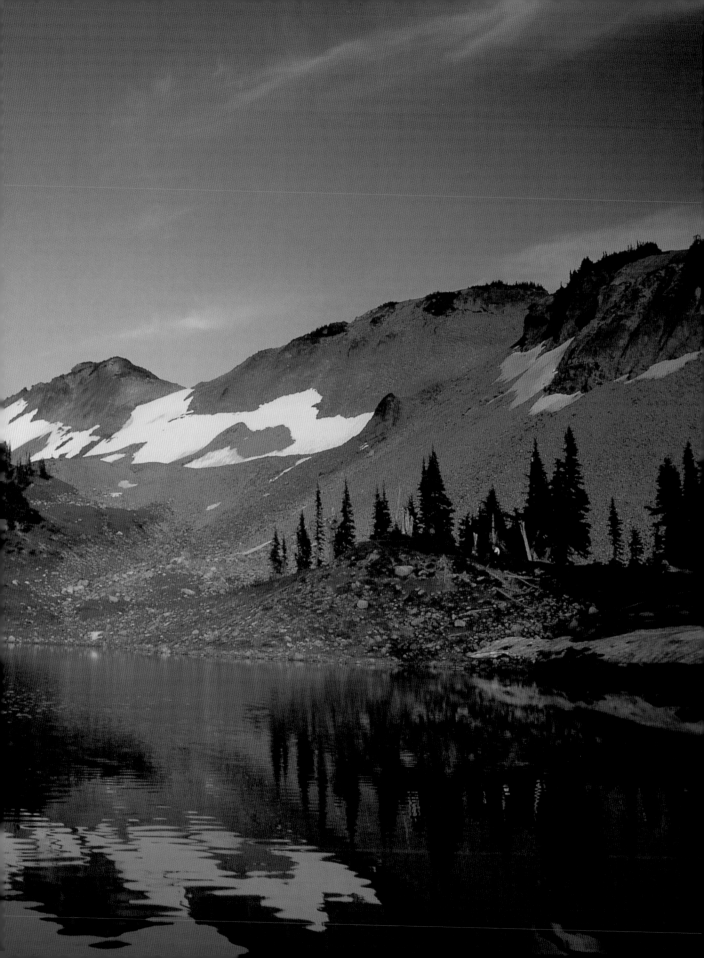

seemingly bottomless depth) and followed it until he could climb the vertical wall upward and tunnel his way through the snow bridge above. But now he had to recross the very snow bridge that had partially collapsed under him. I tossed him my end of the rope. He tied into that and untied his old end so I could pull it through the tunnel. Then he picked what seemed the thickest part of the bridge and crawled across flat on his belly, spreading his weight over a maximum of surface area.

While immensely relieved, we soon remembered we were still well above 13,000 feet and in the middle of what now felt like a minefield. We'd seen no hint of the crevasse Nicho had fallen into, but Nicho believed there were more of the same in the direction we had been walking. We cut a new angle toward the Emmons Glacier descent route as the cold pressed deeper into our clothes and the snow reddened with the setting sun. The upper Emmons was broken into a confusing mess and soon we reached an impasse at a ten-foot-wide crevasse. We looked for alternatives, then decided the most efficient thing was just to jump. The other side of the gap was five feet lower. Nicho positioned himself to belay me with the rope, then fed me some slack. I took a running leap, flailing through the air, and landed with my axe *kachunking* into the other side. Safe. Now it was my turn to belay, and Nicho performed a flawless jump of his own. We paused only long enough to slap each other's backs, then down we raced into gathering dusk.

Our headlamps and the stars above took over as the sun turned its attention toward distant lands. The nighttime glacier froze hard and every step downward jarred at knees and tired muscles. At increasingly frequent intervals we'd stop and sit on the ice to rest, then force the downward march again. Though our goal had been to reach the White River campground that night, we sacked out instead at Camp Schurman, the traditional high camp for the Emmons route. There we stuck our feet in our rucksacks and pulled ourselves as deeply as we could into down jackets.

When John Muir came down from his ascent of Mount Rainier in 1888, he wrote that "happy . . . is the man to whom lofty mountain-tops are within reach, for the lights that shine there illumine all that lies below." During our night at Camp Schurman, the wind howled and the stars drifted like suspended snowflakes in a fathomless crystal bowl. Occasionally we slept. It had been a full mountain day on one of the world's classic peaks. We were boundlessly happy.

Right: *A cold sunrise greets an early season camper.*

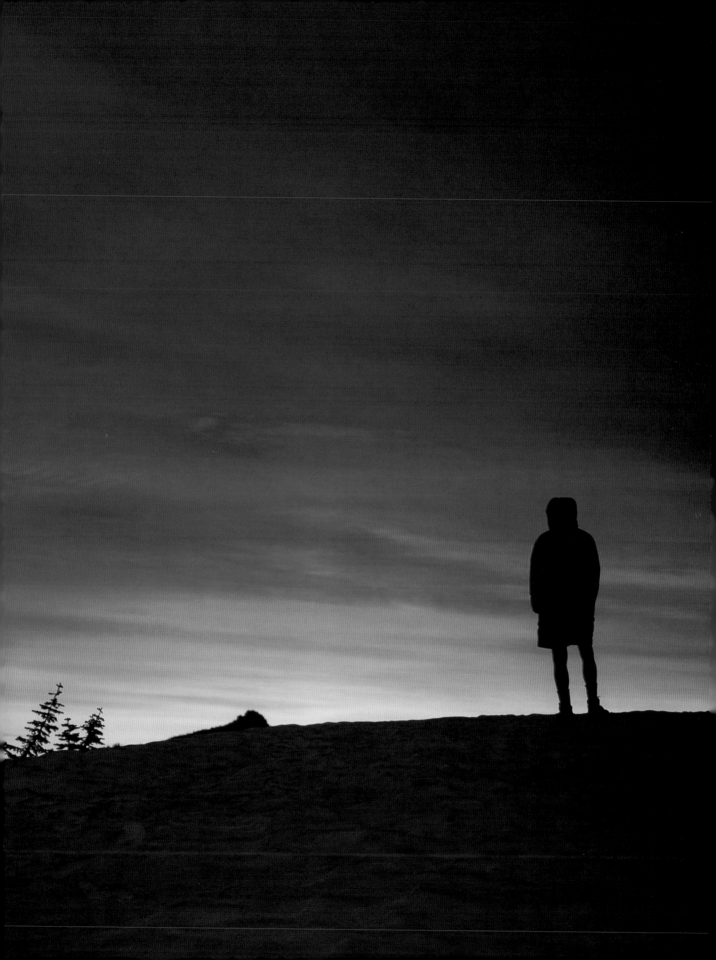

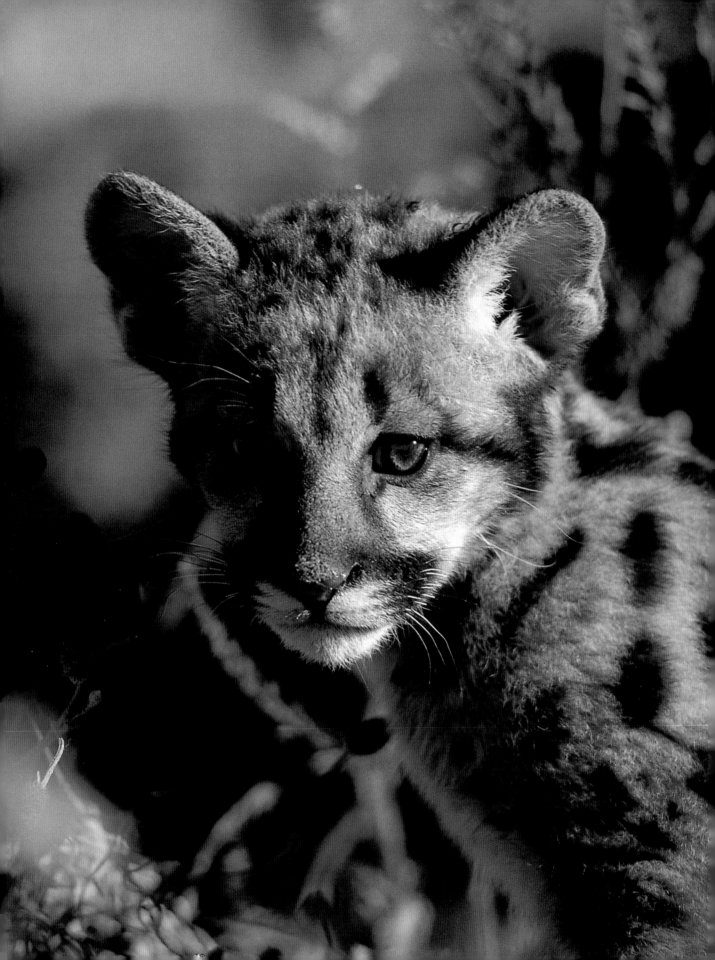

The Wonderland Trail

"This is the kind of parkland

from which the word 'park'—as in

national—takes its spiritual meaning."

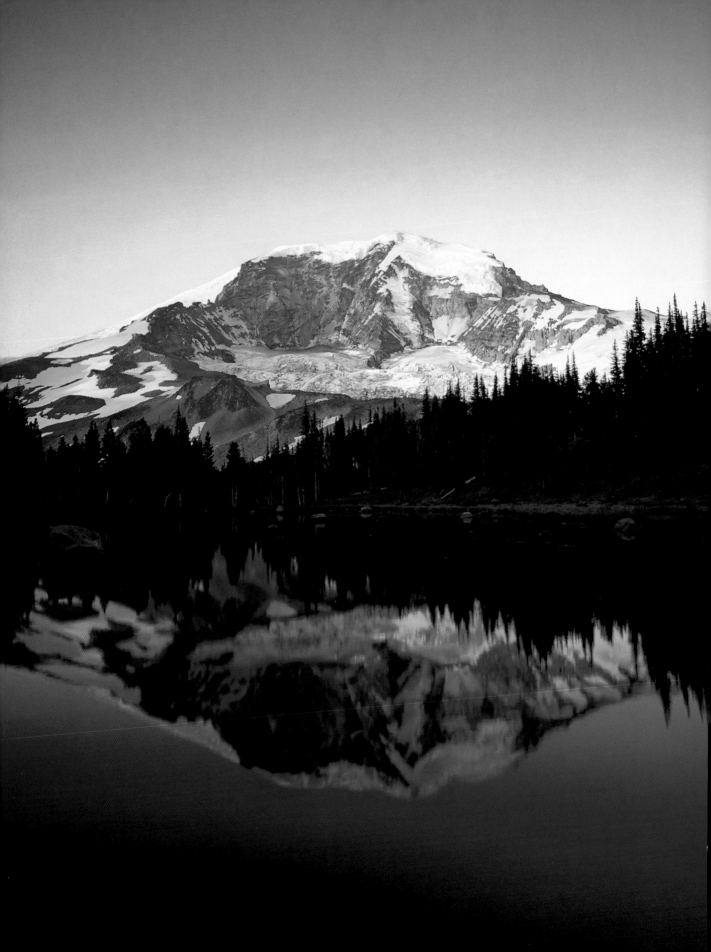

the wonderland trail

Sooner or later, every lover of the outdoors will flirt with Rainier's great spreading skirts. Who wouldn't want to dance with this matriarch of American volcanism? In the Puget Sound basin, where a healthy percentage of the more than 3 million residents immigrated specifically for the region's big trees, big forests, big rivers, and, above them all, big mountains, just the emergence from cloud of the Mountain is enough to make a thousand cars suddenly lurch toward the Enumclaw exit on Interstate 5.

Even where I live, eighty miles south of the park's boundaries, I can study Rainier whenever I hike up one of my neighboring ridgelines. Twice in

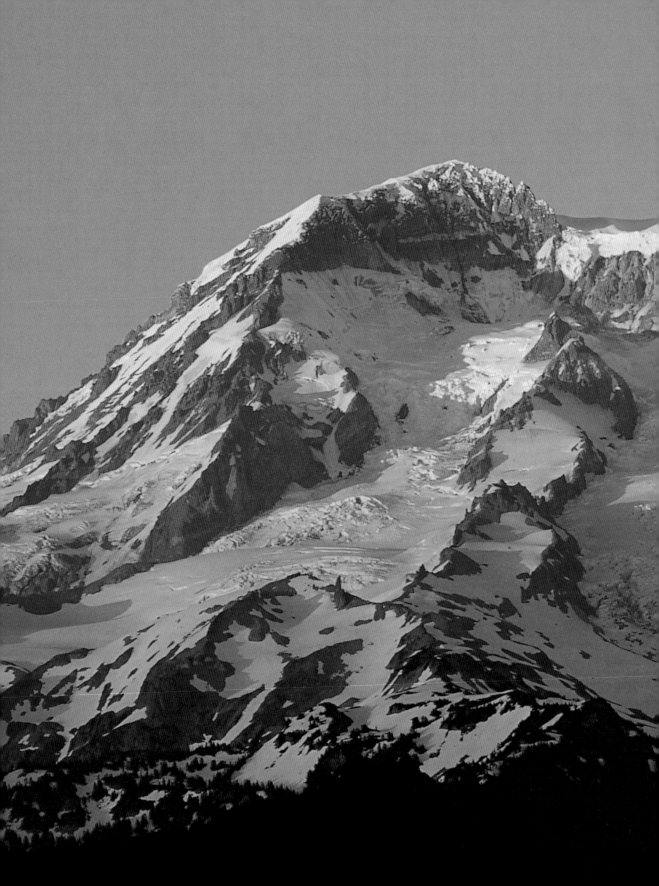

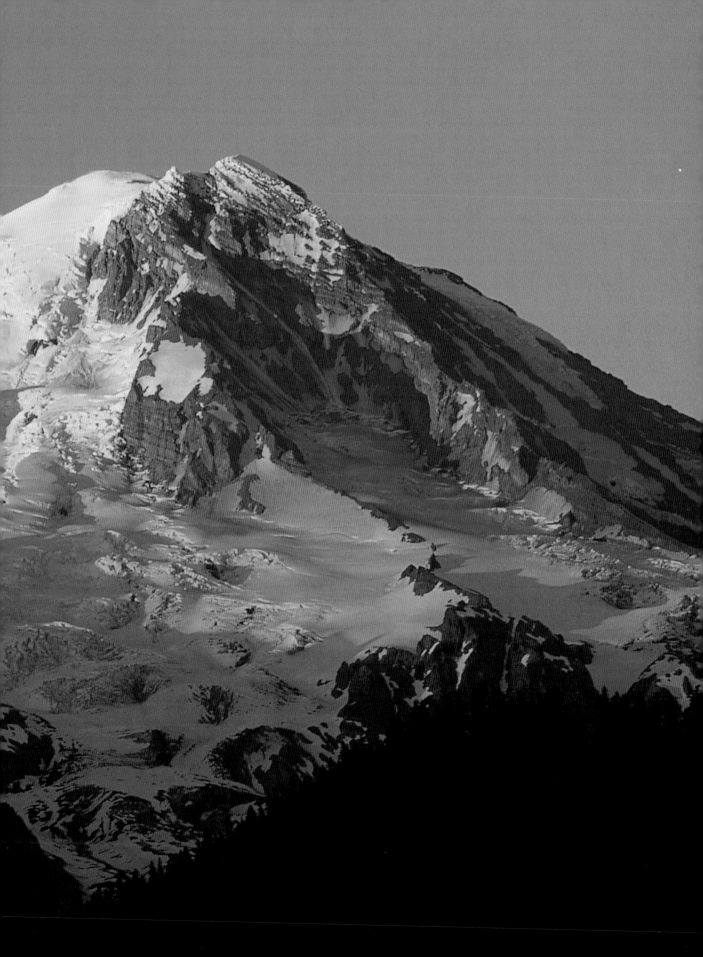

recent years, Rainier's rosy alpenglow lured me to climb to the summit crater. But the more ambitious undertaking, the one that was intended to reveal the Mountain in all her glory, eluded me until one October when finally I could pursue the entire ninety-three-mile round-the-mountain Wonderland Trail. On that famous hike I expected to enjoy places more complex and subtle than the clashing crescendos of the high-altitude stage I was used to. I wanted to spend time in gentler realms, down in the green world of the living.

I decided to step onto the Wonderland carousel at the Sunrise Visitor Center, nestled on the mountain's northeast knee. The weather was predicted to be foul for the next few days, but that's all the time I had available for hiking. Reports called for rain down low and snow up high, and a half inch of early season slush befell me during the night at 6,300 feet at Sunrise Camp. Because true season-ending, hike-terminating snow could fall at any time, I punched hard and fast, intending to complete my clockwise walk around the mountain in five days. It would be a strong clip, especially since October daylight near the 49th parallel is too short for big trail mileage. But my pace would be a turtle's crawl compared with the record, which jogs in at just under twenty-eight hours. Ten to twelve days is a common circum-footing time frame, but as there was no Indian summer in my forecast, I felt five days would be quite enough to drown my patience for storm or drizzle. Of course I was secretly hoping to get lucky, with the Mountain rewarding my devotion by lifting her gray gown briefly, if only to preserve her reputation as a temptress.

To imagine how this circle hike works, first you must throw out any notions of describing the smooth base of a dome. Instead, do this: Hold your palms together in prayer (for sunshine?). Then point your fingers toward the ground. Open your hands, keeping your wrists in contact, and fan your fingers as wide as possible. The fleshy part of your hand (above your fingers) is the upper mountain, encased in thirty-seven square miles of glacier ice, much more than any other mountain in the Lower 48. Your fingers are all the ridges extending out of the mountain, with rivers carving the spaces between them. A summit climber merely has to labor 9,000 feet up in a day or two, then waddle back down on wobbly knees. A Wonderland hiker takes ninety-three miles to weave up and over and down and in and around

Right: *Morning dew adorns a lone anemone near Paradise.*

Following page: *Fire lookouts once enjoyed a panoramic view of Rainier and the Tatoosh Range from the summit of Shriner Peak.*

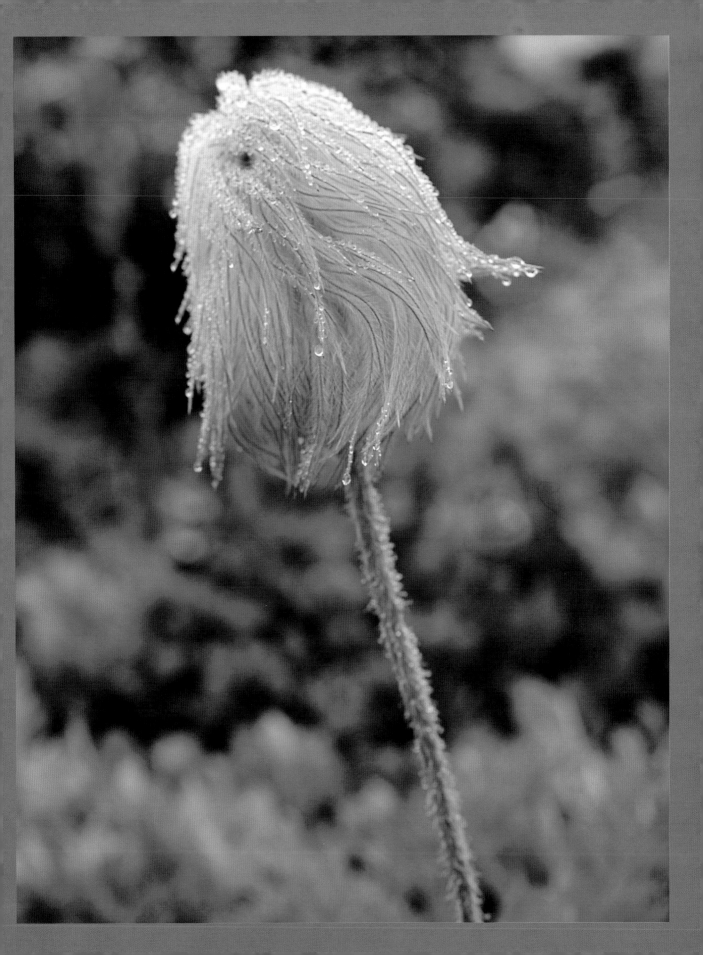

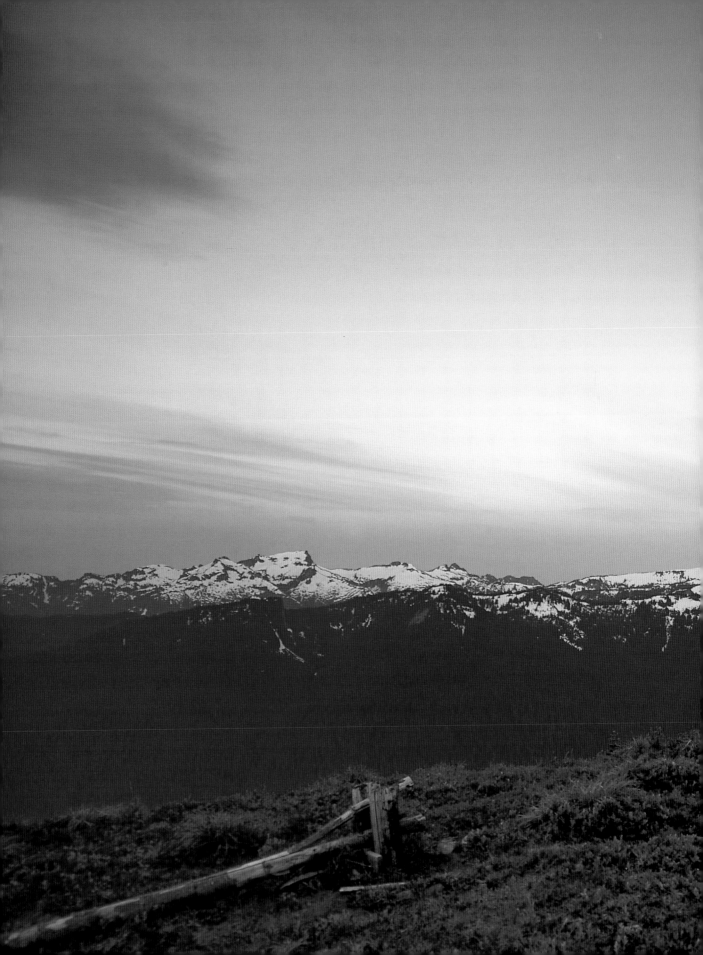

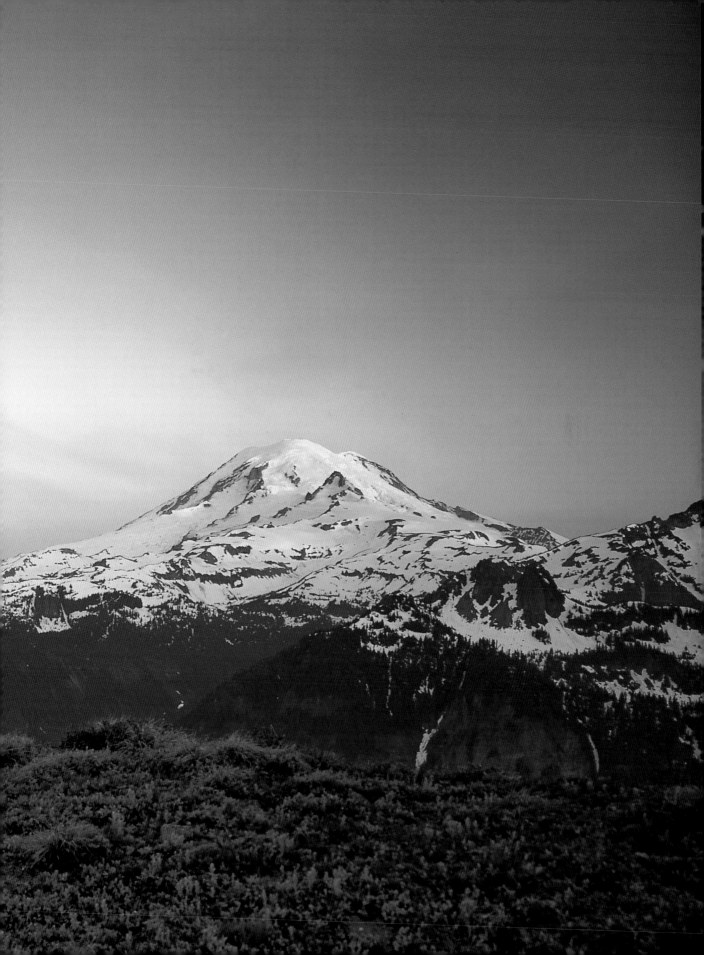

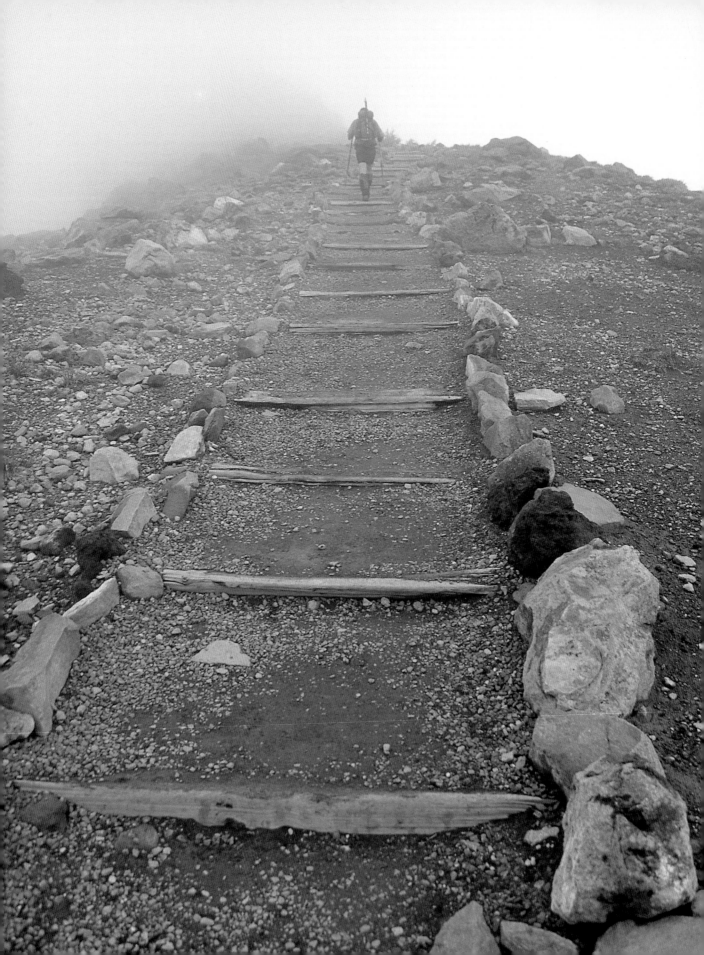

and out every one of the five major river drainages and dozens of tributary forks. The mountain's entire footprint is said to be one hundred square miles. Navigating this merry-go-round results in nearly 23,000 feet of vertical gain—and an equal loss. It's like climbing to the summit from the roadhead at Paradise two and a half times, and then coming down again. Oh yes, and don't forget seventy or eighty more miles of hiking than a climber has to do.

The round-the-mountain track was initiated in 1915, when a hundredperson party from the Seattle Mountaineers ceremonially completed the circle in the first-ever loop expedition. The previous year was a busy one as laborers dug fast in anticipation of the baptismal event. They applied their muscle to extending old Indian, mining, hunting, and recreational paths, all of which already laced the foothills. The final route roughly followed an earlier plan for a mountain-looping motor road. Major Hiram Chittenden, of the Army Corps of Engineers, had completed Yellowstone National Park's scenic byway and he hoped for even greater splendors beneath Rainier. Conservationists, led by the Mountaineers, blocked Chittenden's plan, but for eighty-five years the Wonderland Trail contained at least a short piece of road, the 1.3 miles from the White River bridge to the Summer Land trailhead. Thankfully this last gap in the dirt was eliminated in 2000, finally completing the great project.

Left: A lone climber toils up the trail to the Muir Snowfield above Paradise. He must climb almost a vertical mile to reach Camp Muir.

As I dropped from the fresh October slush of Sunrise into the rain of White River Valley, then drizzled my way up to Summer Land, crossed into the misty fog of snowbound Panhandle Gap far above timberline, descended long ridgelines to Indian Bar Camp, and continued down even longer, sharper ridges to Nickel Creek, I could only assume the slope on my right kept rising until rain turned to snow, snow built to ice, and ice compressed into glaciers. Even without a mountain backdrop there was a spellbinding quality to this timberline country. I fell so in love with the rolling tundra fields of Summer Land and the endless ridgetop walking near Indian Bar Camp that I vowed on a stack of sunny Sundays to return here with my family. This is the kind of parkland from which the word "park"—as in national—takes its spiritual meaning. Even on a gloomy October day, you can feel the magic in glades of wind-dwarfed conifers and meadows goldenhued in the final energy-storing phase of their seasonal cycle. Replace gray

with blue, precipitation with streaming photons, and empty canvas with the sharp outlines of a vertical mile of tumbling glaciers, and you'd surely have one of the scenic highlights of this fair planet. It must be awesome; I've seen the postcards.

The next day I found myself standing at Reflection Lakes, staring at a metal sign beside the water. Printed on the sign was a color photograph of the lake before me. In the upper half was a glowing dome of crags and glaciers. The lower half of the picture held a perfect reflection trapped on a dawn-calm pond. I had to laugh, as behind the sign today was nothing but an infinity of expanding raindrop ripples, and above that a tomb of dripping gray. As sweat from long miles of uphill travel condensed inside my rain jacket, perhaps my mind drifted wistfully to stepping offstage here at Paradise, where my trail crossed a road. Surely someone would take pity on a drenched-looking backpacker and give him a ride back to his car at Sunrise? Alas, I was dry enough inside my high-tech togs, so that excuse didn't work. Besides, I told myself, weather is as much a part of the mountain as are crumbling ribs of congealed lava. I would finish the dance with my brooding companion, no matter her mood.

There's plenty of logic behind Rainier's infamous temper. This stratus-scraping amazon dominates the nearby salt water of Puget Sound, itself an inward sweep of the vast Pacific. Great ocean clouds that merely brush across Seattle body slam into Mount Rainier. A record ninety-three feet of snow (1,122 inches, to be precise) fell here, near the shores of Reflection Lakes, between July 1971 and July 1972. True, normal years see half that snowfall, but even a Northwesterner has to admit this is a lot of H_2O. The reason for this embarrassment of wetness has much to do with all that sodden Pacific air. But it's not that simple, and Rainier herself is responsible for most of the mess.

To understand how the mountain draws water out of thin air, first notice the patterns. Way down at Longmire (at an elevation of 2,800 feet), a square foot of soil consumes forty-five gallons of precipitation each year. But just a few miles away at Paradise (at 5,400 feet), a square foot drowns in sixty-eight gallons of wet—half again as much. Why the difference? Because when the moist air swoops toward Rainier's lower extremities, it is still ocean-warm; most of its water molecules are in the form of energetic

Right: *The Carbon River winds its way out of the park.*

Following page: *The Carbon's rain forest is the lushest valley in the park.*

vapor (think steam). But then the air bumps against Rainier and is pushed upward. As air rises, it cools, at a rate of about 3.5 degrees Fahrenheit per thousand feet. So, while climbing from Longmire to Paradise, the air cools almost 10 degrees based on simple uplifting, never mind whatever coldness Rainier's frozen glaciers stir into the pot. Water condenses from vapor to liquid as it cools. At first the tiny water droplets show up as clouds, then they stick to each other and grow into fatter droplets until finally they tumble from the sky. If the outside air happens to be below freezing, the precipitation shows up as snow. Lots of it.

It was dark and the rain was falling harder than ever by the time I reached the forested Devils Dream Camp. Over the sound of rain drumming on my parka's hood, I could hear a nearby creek gurgling through the blackness. I spent a few minutes wandering into each of the deserted campsites, looking for the one with the shallowest puddles. At last the tent was up and I could

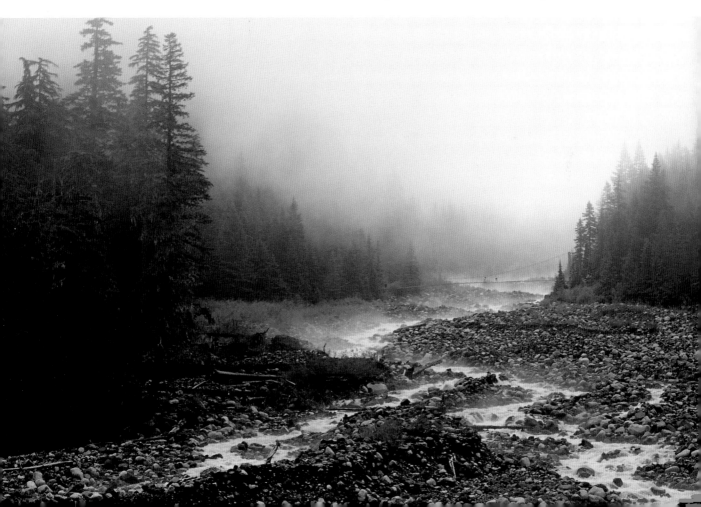

go spelunking in inky forest searching for creek water to replenish what I'd
sweat out while huffing up the hill.

All along my hike, streams provided lively company. I could judge my
progress by the sound of one stream fading behind a ridge and then soon the
next one emerging into my consciousness through the muffling forest and
jacket hood. Streams are inevitable with all this water, and so it's lucky for
backpackers that there's a bridge for nearly every flow. In my rain-fogged
delirium I began greeting them as my "Bridges of Wonderland Country"
and came to view the jumbled collection as jewels in Rainier's Wonderland
necklace. The mind dredges deep as the rainy miles grow long.

But even with a clear head, there's no denying the beauty in those
bridges. Though some seem homely and dispirited, to a ranging backpacker
each bridge offers just the civilizing influence needed in a rough-hewn land-
scape. At first I barely noticed the bridges, which began as skinny logs with
shaved-off tops crossing slender, shallow channels. The logs that had been
used to cross Fryingpan Creek on the way to Summer Land, though, defi-
nitely caught my eye. They had been a foot or two thick, it would appear,
and had spanned perhaps fifty feet. Unfortunately, neither girth nor length
prevented them from being broken like toothpicks by a recent flood. As my
hiking miles rolled by, new bridges piled on; they became an ever-changing
but always welcome signature of Wonderland navigation. Some were
shaved logs cabled together with slender handrails perched between boul-
ders in a floodplain. Some were two-hundred-foot metal suspensions across
deep gorges. A few were mossy wooden planks built for horses but tipping at
a 45-degree angle so that only a cougar's claws could stick to them. There
was an abandoned and overgrown concrete road bridge with decaying bits
of old-growth trusses caught in the canyon walls below. There were flood-
plains with no bridge at all, where careful rock-hopping gets you across on a
good day; wading on a less good day; and you're wise to give up and turn
around on a bad one. Each bridge with its own character, a rich collection
of stories in need of telling.

One bridge stands above all others, and despite the windblown rain I had
to stop and gape downward from the swinging 206-foot span of the Tahoma
Creek suspension. In 1987 a day-hiking couple crossed this chasm when it
looked much like it did as I stood there—more than a hundred feet deep,
with a chocolate-brown torrent cutting the bottom. An hour or so later, the
hikers returned to find water passing just twenty feet under the decking.
House-size boulders bounced in the maelstrom, and basketball-size rocks

Right: A small creek exits near Moraine Park as the clouds descend.

Following page: Monkey flower and an anemone commonly called a "towhead baby" fringe the Paradise River.

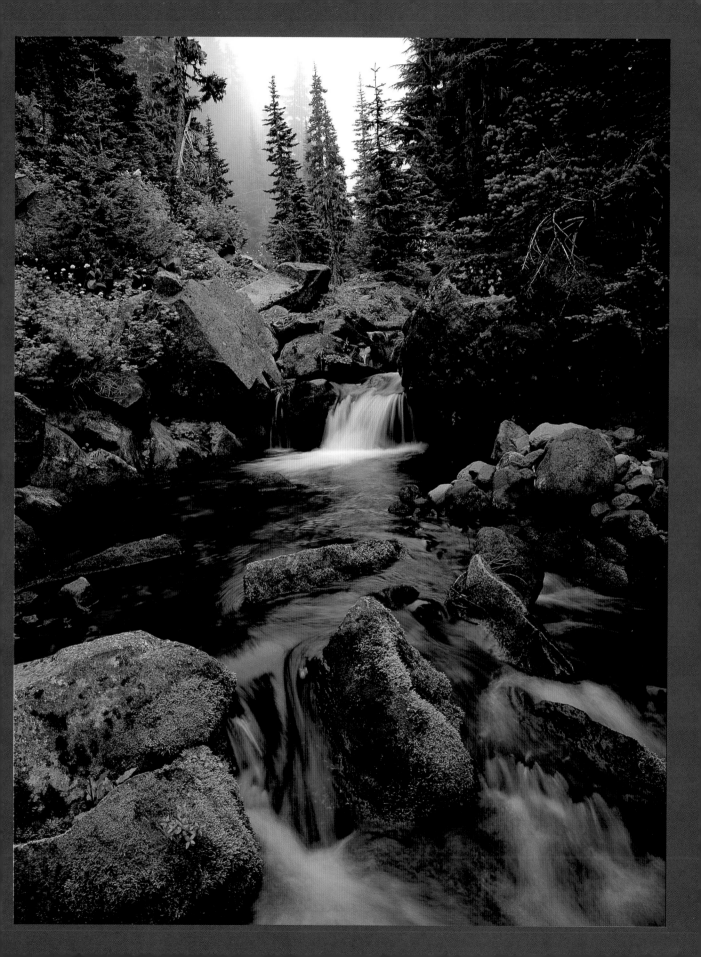

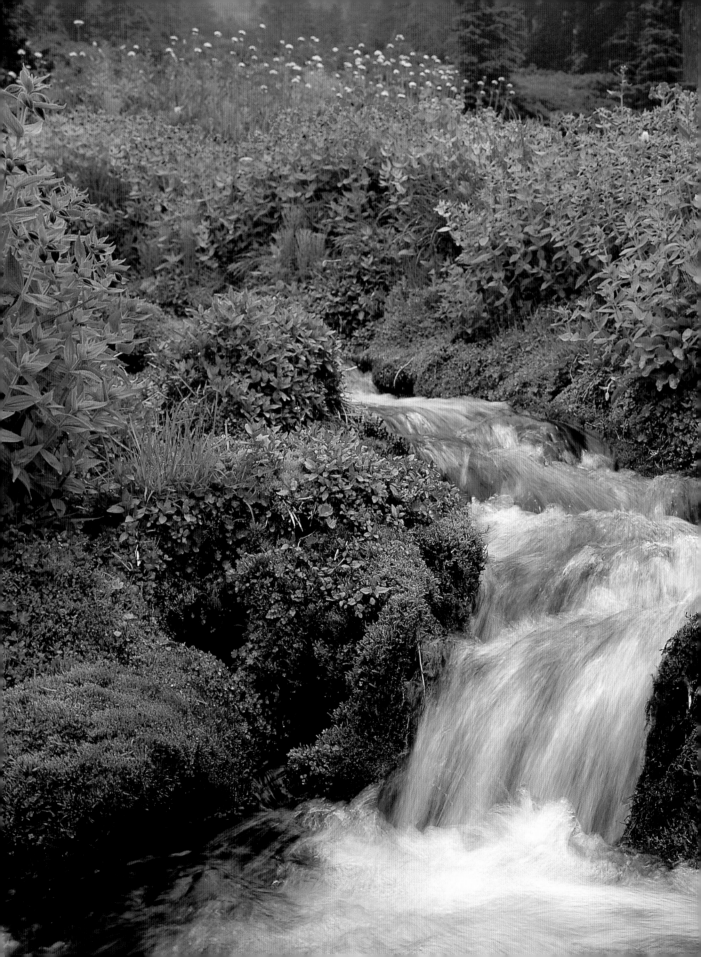

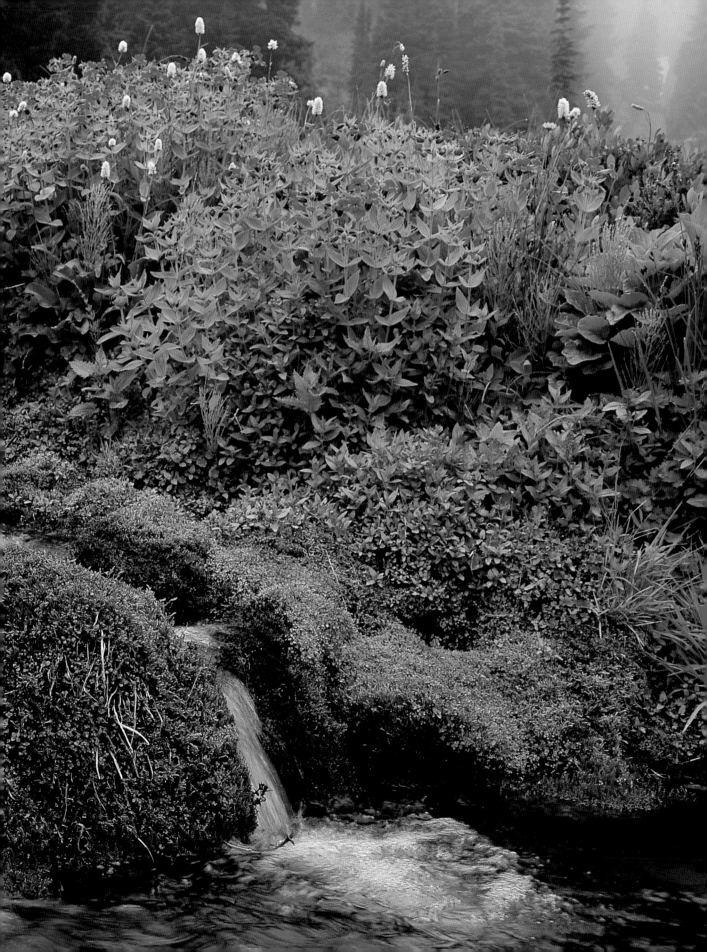

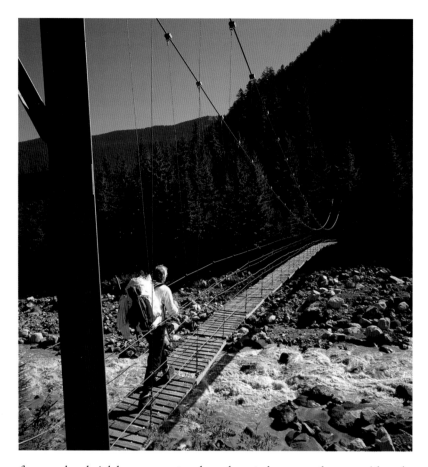

flew overhead. A lahar was passing through, as it does every few years (though rarely this massively) when trapped rain and meltwater inside a glacier break loose and carry away chunks of mountain. Indeed, this Tahoma Creek gorge doubled in depth during the 1980s, thanks to the scouring effects of exceptionally frequent lahars. A campground just downstream is now filled with room-size boulders and is strictly off-limits to tenting.

During the most spectacular prehistoric lahar, a concrete-like mixture of mud and water five hundred feet deep rushed over the future home of White River Campground and didn't stop until it rearranged the shoreline of Puget Sound, fifty miles away. When—not if—Mount Rainier decides to warm up again in a fit of volcanic pique, massive lahars pose a vastly greater threat to the Seattle–Tacoma urban sprawl than do ash and flying magma. Rainier isn't the most likely to blow soon—Mount St. Helens still is—but geologists consider it by far the most potentially dangerous American volcano, since activity could melt its thick mantle of ice and threaten the many thousands of people who live downstream. It's unlikely anything as

Left: *A hiker crosses the Carbon River suspension bridge on the Wonderland Trail.*

Right: *Mud and bog often demand the construction of bridges and walkways in canyon bottomland.*

enormous as that ancient flow would take place today—the Osceola Mudflow of 5,700 years ago apparently shortened Rainier's summit height from 16,000 feet to near its current 14,410. But it wouldn't take a new shoreline in Puget Sound to crush thousands of homes in the lowlands of Rainier's great rivers.

My eyes were on the trail as I hiked through ragged little clouds slipping between dwarf timberline conifers. Suddenly something dark moved at the edge of my sight. I glanced up to catch sight of a mother black bear and her two cubs as they swiveled in place and ran away from me. We were a hundred yards apart, but that was too close for her. I was glad for her shyness as I watched the powerful sweep of the sow's huge forelegs. As I stood there alone, the immensity of this bruin appearing from and then vanishing into

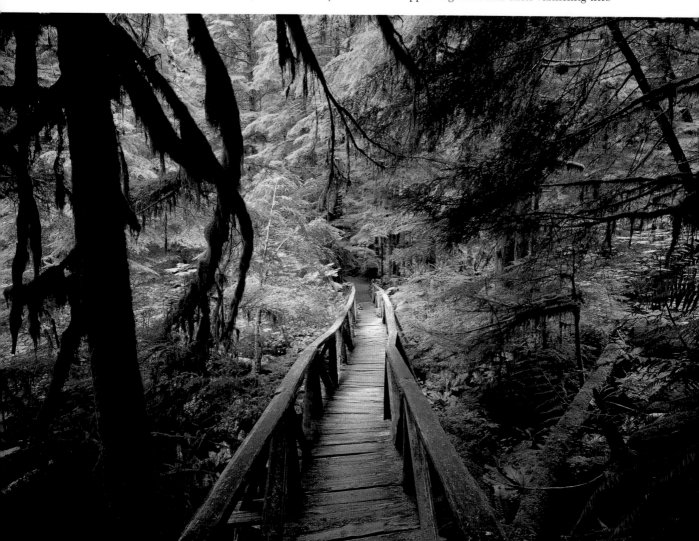

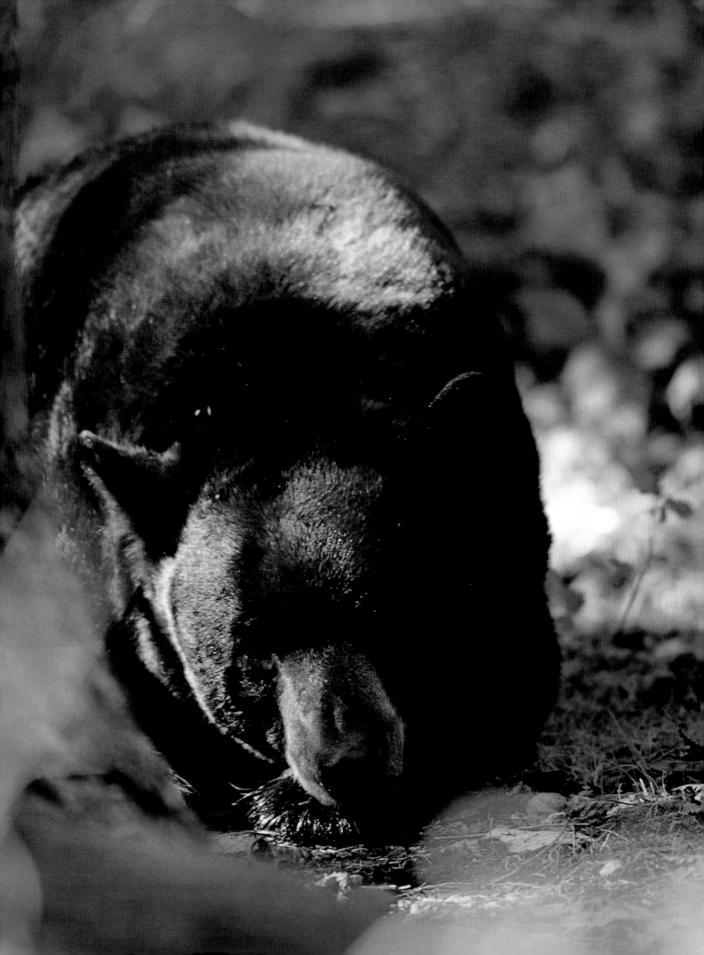

the fog reminded me more of grizzlies I've fearfully admired in Alaska than of the black bears I've encountered elsewhere.

The weather finally broke about a half hour before sunset and my arrival into the Golden Lakes campsite. Through thinning clouds, amber light filtered onto October-red huckleberry fields, lifting my spirits faster than the sun could drop. A blanket of stars appeared and in their glow I could make out at last the huge bulk of Mount Rainier taunting me about views so far unrevealed, and promising (teasing?) that my luck might change. That night came heavy frost, my final test, but it seemed the Mountain was anointing me a worthy suitor, perhaps for having endured her water gauntlet. Striking out just after dawn in sparkling yellow light, I rejoiced as low-flung sun rays grazed frost crystals and glowed the fields of autumn huckleberry. Above me a blinding 14,000-foot apparition shimmered against a royal sky. My eyes could only squint at the unaccustomed brilliance and scale of these surroundings.

Even when the Mountain had been cloaked in gray, she was never dull. Every passage upward or downward would bring me through characteristic life zones, each with its great community of species that live together and are distinguished from other communities by the altitude they keep. Down low, I'd waltz through the western hemlock life zone, enjoying a gentle pace beneath its stately old growth. In the few nooks where the Wonderland dips to 3,000 feet, trees can shoot dark trunks one hundred, even two hundred, feet skyward. Some lowland giants have grown for a thousand years, protected from fires in the isolation of their warped terrain. At the feet of these ancients is a rich green shag of vine maple, salal, Oregon grape, and huckleberry. Then, as I climbed between invisible contour lines, the music would change as well. Soon I'd move to the diverse rhythms of the Pacific silver fir zone, which filled the interval from 3,000 to 4,500 feet with its eponymous fir, and also with noble fir, western hemlock, Douglas fir, and the occasional western white pine. Many switchbacks later I found the dance hall draftier and my tempo would speed up to keep pace with the mountain hemlock zone, whose namesake tree mixed with Pacific silver fir and Alaska cedar until increasing winter snow depths and a shortening summer growing season set an upper limit on tree survival. Here, in the range of 5,200 to 6,500 feet (precise elevations depend on sun and wind exposure), lie the great timberline parklands that I'd first fallen in love with back at Summer Land and that elsewhere earned the title "Paradise."

The Wonderland Trail's Spray Park cutoff slices across one of those grand

Left: *Black bears, while less aggressive than grizzlies, can be more dangerous when provoked.*

Following page: *A hiker breaks out of forest and into Spray Park, one of the glorious high gardens in the park.*

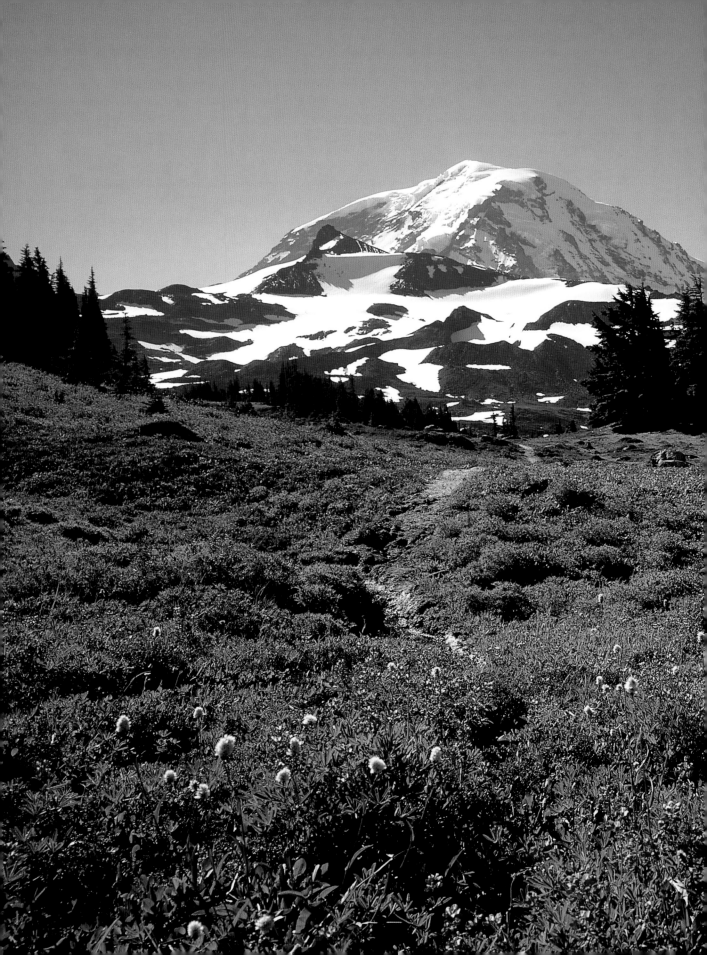

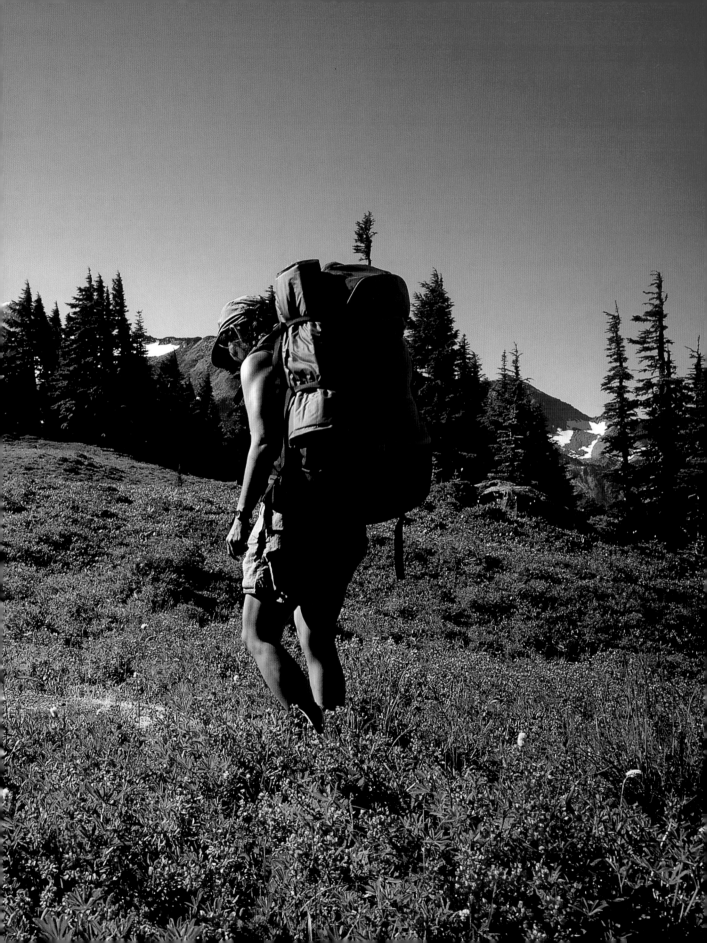

parklands where meadows are inlaid into a patchwork of stunted conifers. Gradually as I moved upward, the percentage of meadow increased and the trees shrank to scrub and then the meadow became tundra that in turn vanished under a permanent snow patch. My October hike occurred late in the seasonal life of a flower, but during more youthful times these timberline meadows riot with color. When John Muir made Rainier's sixth ascent, in 1888, he wrote that crossing Paradise they stepped through a "garden knee-deep with fresh, lovely flowers of every hue, the most luxuriant and the most extravagantly beautiful of all the alpine gardens I ever beheld in all my mountain wanderings." Muir couldn't help but contrast such living glories with Rainier's austere summit, and he rightly concluded that "apart from . . . [the] exhilaration of climbing, more pleasure is to be found at the foot of mountains than on their frozen tops."

As I began descending toward tree line on the north side of Spray Park, I noticed some furry scat in the trail and walked on by. Then it occurred to me that this was no ordinary dung, and I hiked back for a closer look. Projecting from the hair was a small deer hoof and several two-inch-long

Below: *Marmots interrupt their foraging to whistle warnings as hikers draw near.*

Right: *Spray Falls is one of the tallest waterfalls in the park.*

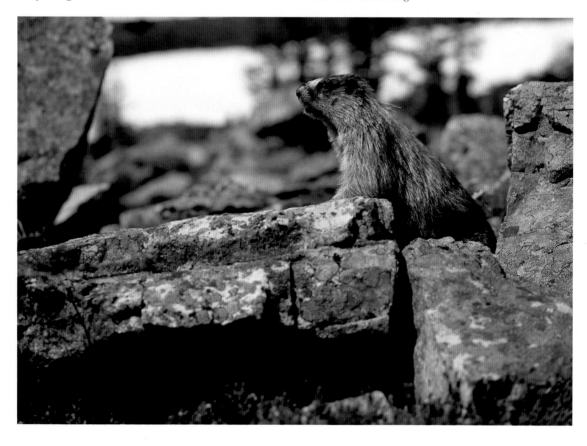

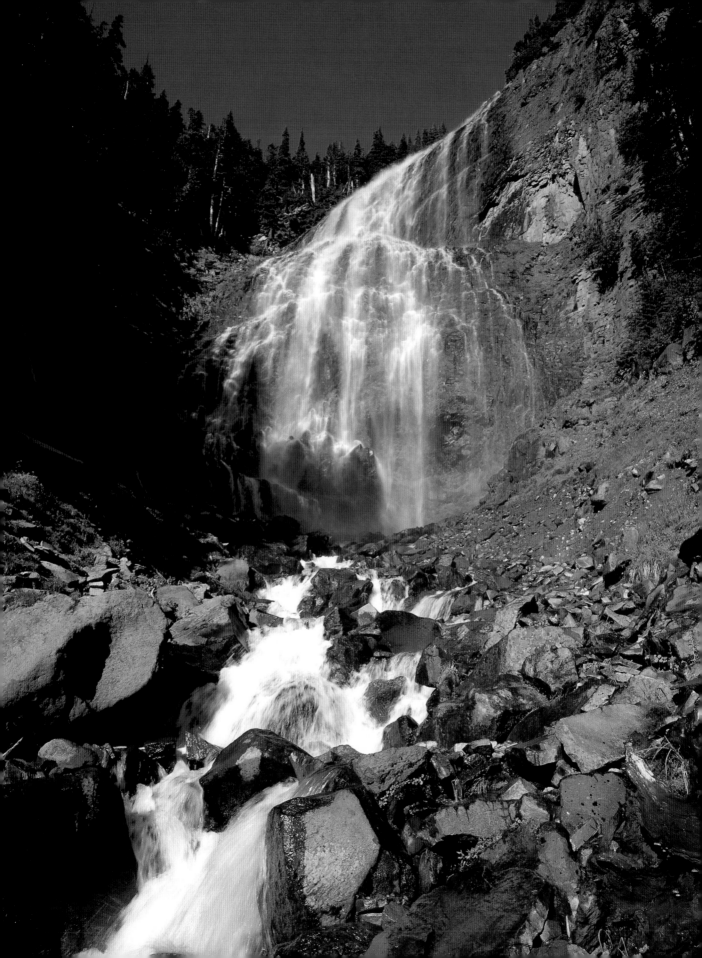

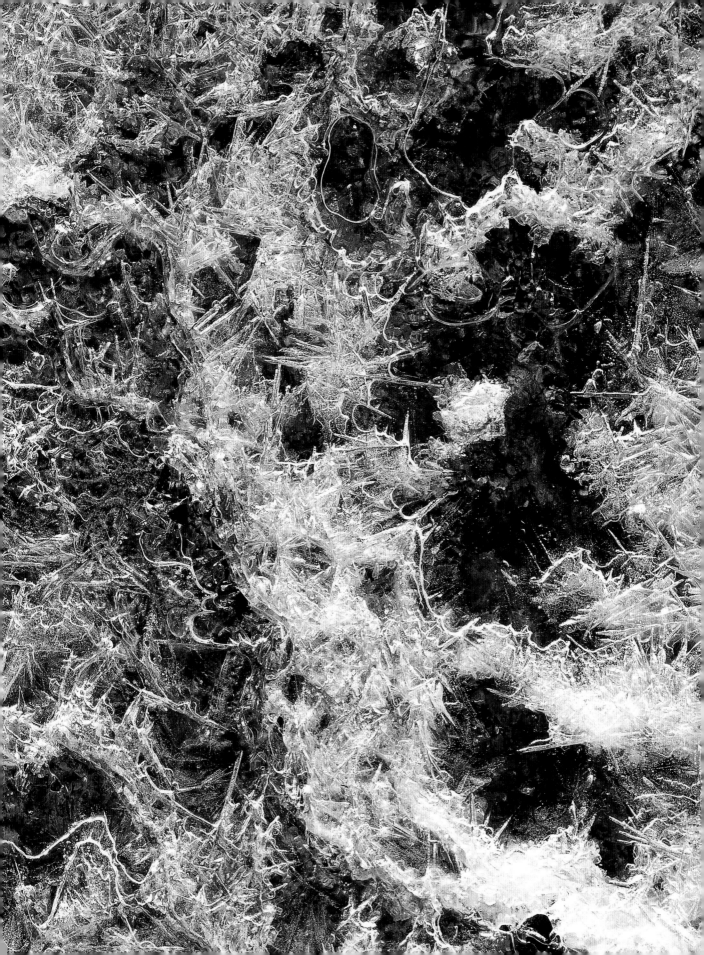

pieces of bone. This dropping was much bigger than anything a coyote would leave behind, and smaller than a bear's. My imagination raced to scat like this I'd seen in Alaska and British Columbia: wolf. But no, not here, where the last big wild canine was exterminated almost a century ago. Confused, I picked at the dropping with a stick, and then it dawned on me: mountain lion, also known as cougar. I wouldn't have thought of big cats above timberline, but it made sense. It could have devoured the fawn and its hoof at any altitude, but up here the big cat probably had plumper, softer prey in mind, like the critters who had been whistling at me for much of my journey. Marmots are perfectly adapted to the hard high life, where summer is a time of feasting and the rest of the year is famine. During the many months when all things lie buried under a heavy snowpack, the marmot simply hibernates, sleeping on its fat reserves until summer sun brings its world back to life. My musical October companions waddled between burrows, waiting for the kitchen to close on their annual feeding orgy. To a cougar, the marmot's whistle must sound like a can opener working a tin of Friskies.

Morning found me toiling upward again, making the gradual 3,800-vertical-foot trek alongside the Carbon Glacier. I reflected back to my experience crossing the Carbon on my way to the base of the Liberty Ridge, but even that adventure did not prepare me for the fearsome nature of this filthy snout. Only occasionally did dark ice peek through the massive load of rubble on its surface. There is nothing elegant about the Carbon's terminus; it is simply a hideous conveyor belt belching forth the fruits of its strip-mining labors. The glacier carries not only everything currently tumbling off the vast and rotten expanse of the Willis Wall, but also the rubble from an immense 1916 rock slide that swept a major part of the face down onto the upper Carbon. As a result of this insulating rock layer, in addition to the tremendous depth of the ice itself—the basin under the north wall is filled seven hundred feet deep with ice—the Carbon today reaches down to an altitude of 3,600 feet before summer melt outpaces the inflow of ice from above. That's a low-altitude record for glaciers in the Lower 48, and the Wonderland Trail gives one plenty of hiking time to appreciate the glacier's staying power.

While Rainier's glaciers have been in overall retreat since the end of the Little Ice Age about a hundred fifty years ago, they sometimes go on a

Left: Ice crystals form during the chilly nights of early autumn high on Sourdough Ridge.

Following page: *From Mazama Ridge, Louise Lake captures the blue of the summer sky.*

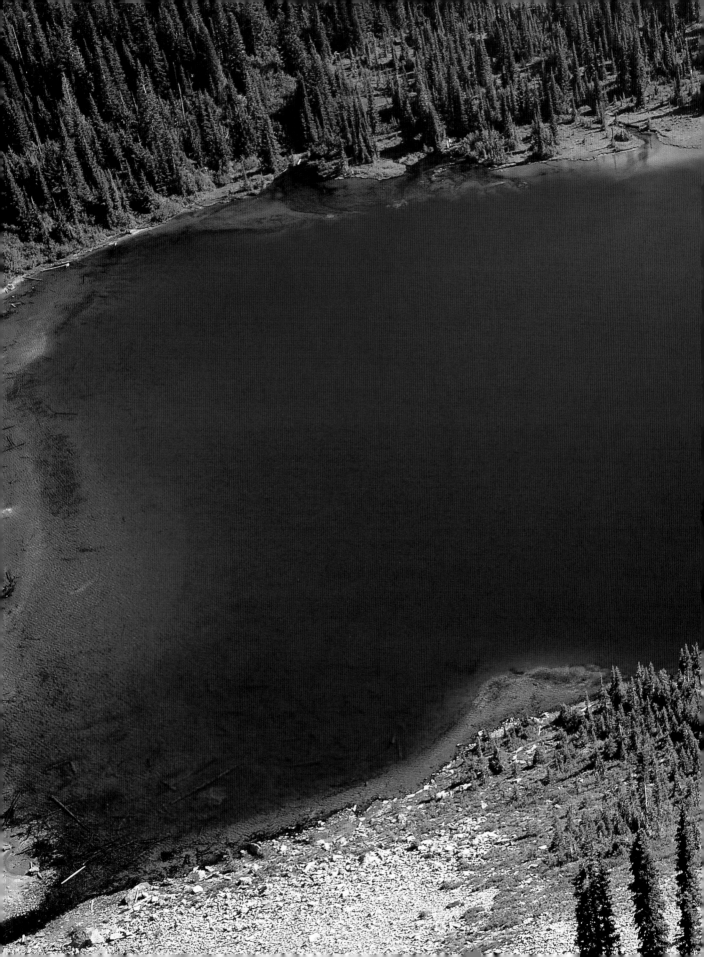

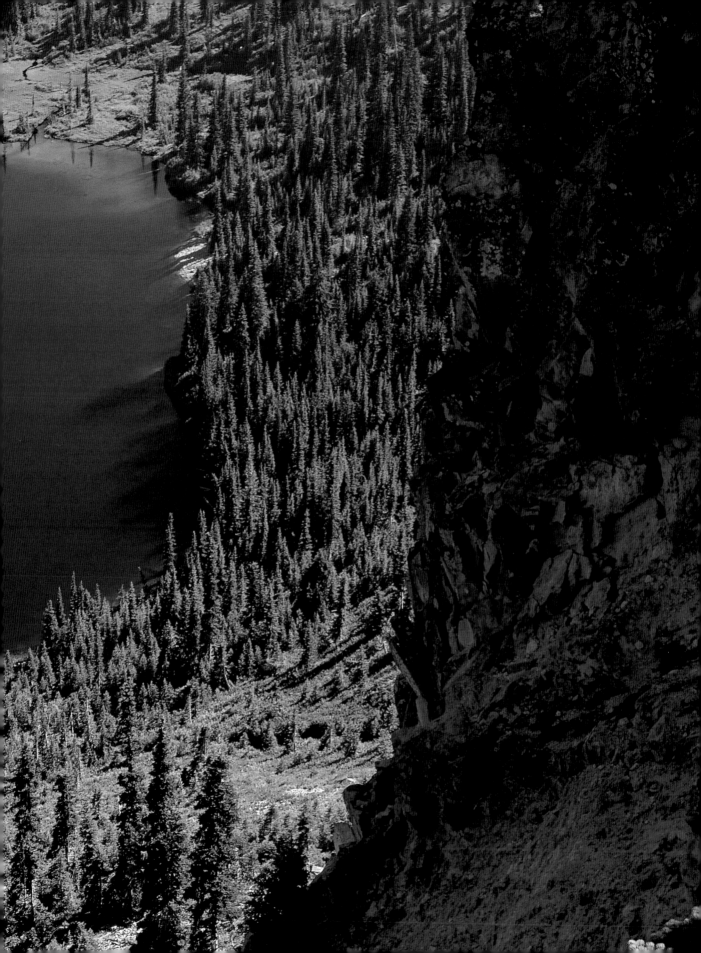

creeping rampage even in modern times. During the 1970s the Carbon moved forward so rapidly that visitors could watch vegetation being crushed by rockfall off the glacier's advancing end. At that time the Nisqually Glacier was measured slithering forward some twenty-nine inches per day—a crowd-pleasing sprint by glacier standards. More typical today is half that pace, except over steep passages where the speed hits nearly six feet per day. But the Northwest's atmosphere has warmed and dried since the mid '70s, and some glaciers have retreated into history. During Muir's time there were twenty-eight named glaciers on the mountain; now there are only twenty-five, and even the mighty Nisqually has shrunk a mile since 1907.

Worldwide, glaciers have been in rapid retreat during the last century due to global warming, but in wet climes like Washington's, most ice-rivers will endure. It's not just cold that builds a glacier; there must also be new snow. As long as moist air rolls in off the Pacific, and as long as this air is forced to climb over Rainier, fantastic volumes of snow will bury the mountain. The snow will compress to ice, and the ice will flow downhill in the form of glaciers. Even as dry Arctic glaciers shrivel and die, the Carbon will continue to quarry deeper into the mother of all Northwest mountains.

Rounding the final tundra-filled miles above Berkeley Park and heading back to my starting point at Sunrise, I watched clouds whisping over the mountain. They quickly built into a heavy blanket, and it was clear that my

Left: *Cascade Range rain forest is some of the toughest jungle in the world for cross-country hikers to traverse.*

Right: *Mount Rainier punches through the clouds in this aerial view.*

Following page: *Early season snow blankets the eastern flank of Mount Rainier, seen here from Shriner Peak.*

great and mostly unseen partner of the last five days would pull the covers; her show was over for late-season voyeurs like me. Instead of bemoaning my earlier bad luck with weather, I felt grateful to have been allowed to wrap up the journey with my eyes lifted out of the mud and filled with the gleam of sparkling fields of snow and ice. There had never been any doubt who was calling the tunes these ninety-three wondrous miles. The Mountain keeps her own company, but as I found out, she'll also entertain a suitor who displays enough devotion.

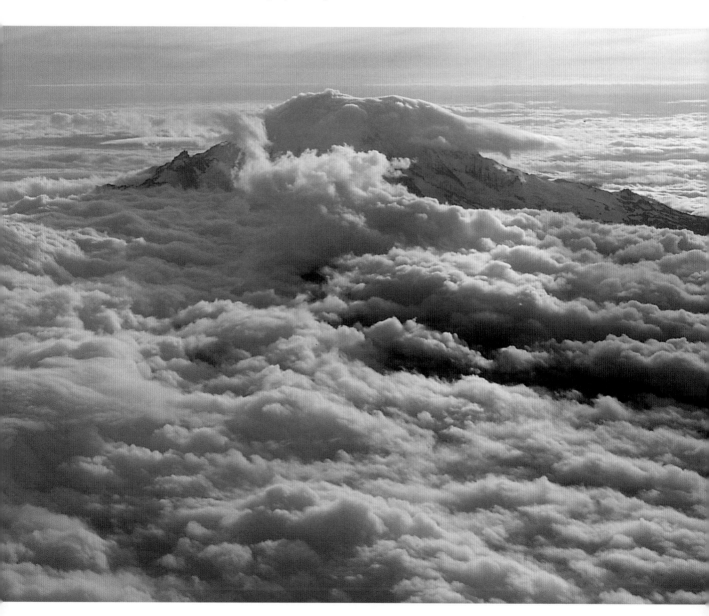

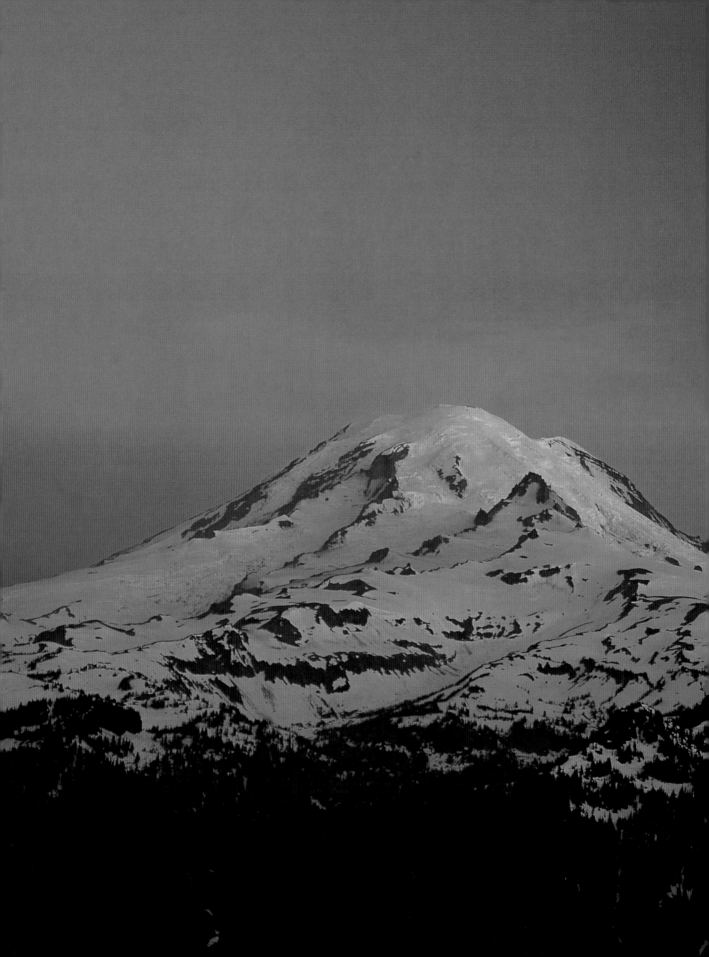

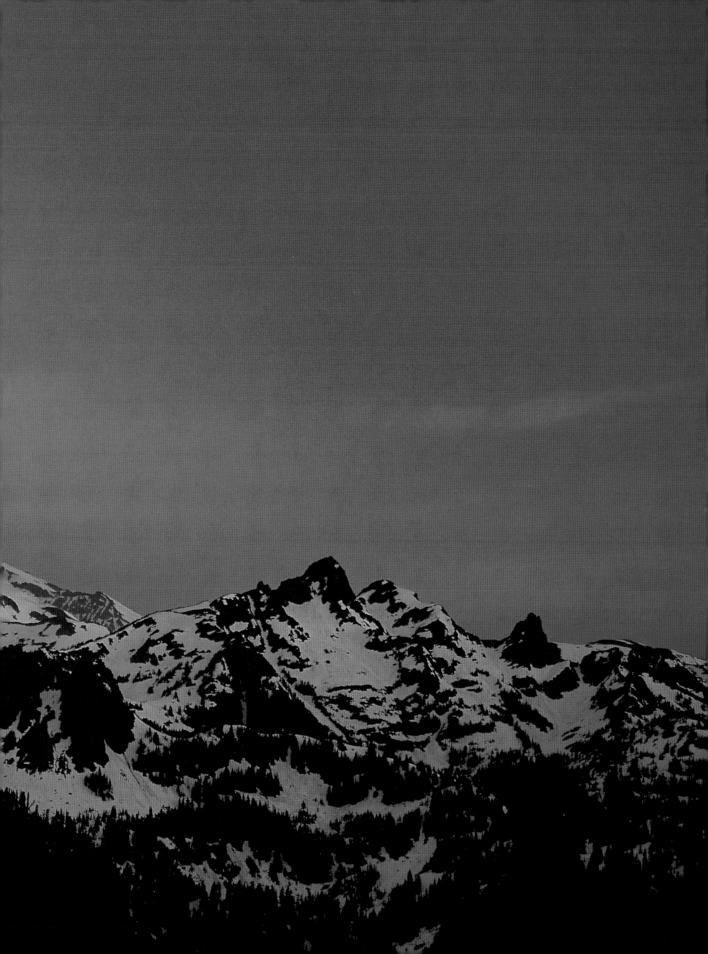

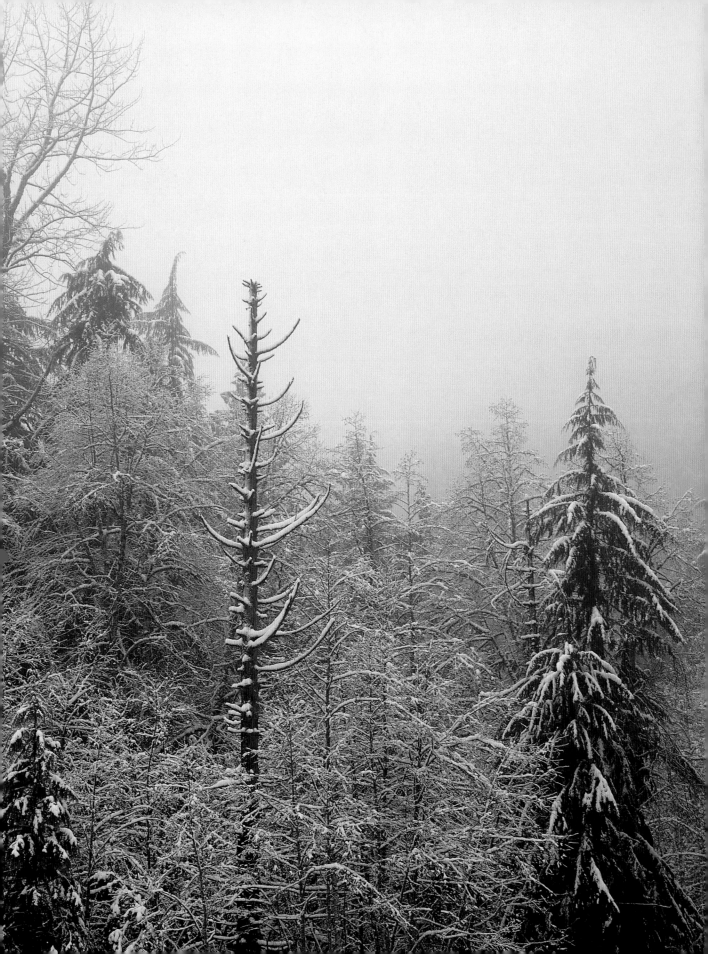

The Climbing Rangers

"That year the wind ripped

so hard that fifty-gallon barrels full

of human waste fluttered in the air at

the end of their tethers."

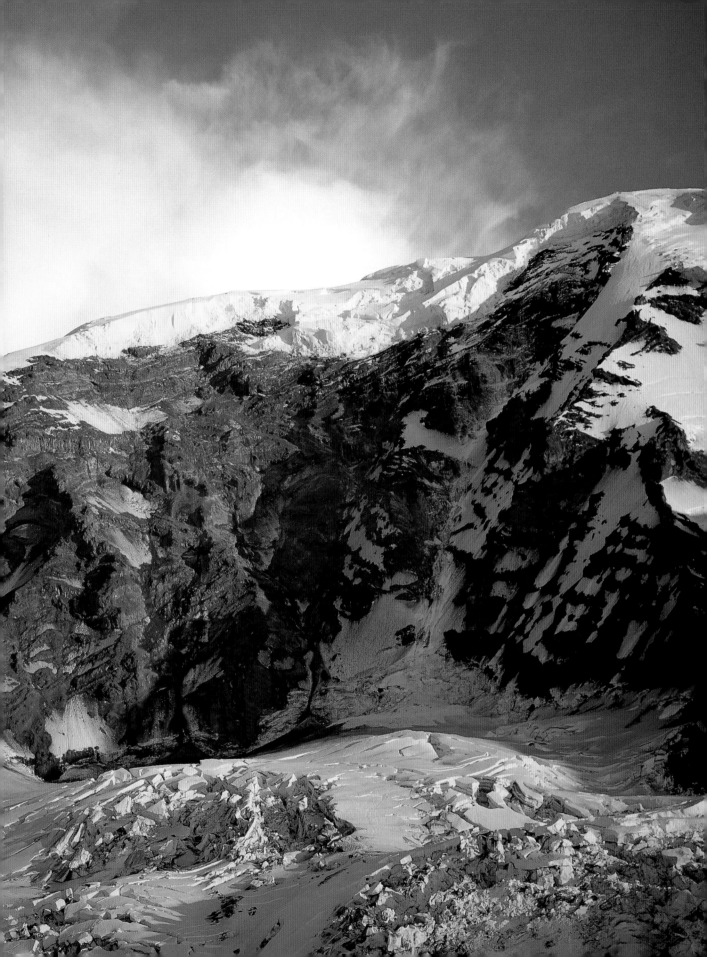

the climbing rangers

"It was as if the mountain was pissed that year," said Mike Gauthier, looking back on 1999. At the age of thirty-one, Gauthier had for years been Mount Rainier's lead climbing ranger. He earned that distinction with more than a decade of service, more than one hundred fifty summit ascents, nearly as many rescues, and an aggressively positive, take-charge-and-get-things-done attitude. His dark, flashing eyes and highly energized body have been sculpted by the mountain; he knows its many facets probably better than any man ever has. Sure, a couple of much older guides have reached the summit twice as many times, but guides tend

to do a couple of routes again and again until their eyes glaze over. Mike has been everywhere; he literally wrote the book on the topic—*Mount Rainier: A Climbing Guide*.

We were lounging on Mike's couch in his government-issue house in Longmire when our conversation turned to 1999. Mike sat up with a start. "That year," he said, "the mountain seemed to be telling us to go away, to leave it alone." That year a wall blew down on the cement-and-stone rescue hut at Camp Schurman, up at 9,460 feet on the Emmons Glacier—despite being reinforced with steel pipes anchored into the bedrock. That year the wind ripped so hard that fifty-gallon barrels full of human waste fluttered in the air at the end of their tethers. That year the mountain threw victims at Gauthier's staff of twelve climbing rangers with such a vengeance that they never had time for their normal rescue training sessions. Radios crackled with emergency messages in a continuous staccato. Eight people died; ten broke bones, froze body parts, or suffered as all climbers know they might, but would rather read about in someone else's epic.

We were at Mike's house instead of where we had hoped to be: on the mountain for a ski descent from the summit as the year 2000 drew to a close. Alas, successive waves of moisture-laden clouds kept us pinned to powder skiing in the trees during the day and hunkered on Mike's couch at night, telling stories. With us were David Gottlieb, age thirty-three, one of Mike's dirty dozen (also his main climbing partner on and off this particular mountain), and Asha Anderson, twenty-four, a volunteer ranger who for some reason couldn't ski with us. I grew increasingly curious about raven-haired, wide-eyed, tongue-tied Asha. I was told she was a climbing ranger, but every time I asked about it, she alluded to how she didn't go high; didn't do rescues; used to ski, but not that winter. Something about not being able to walk well. Then I learned about the titanium screws in her ankles. Two weeks in the hospital. Two and a half months in a wheelchair. And finally her story came out: November 15, 1999, when she slid six hundred feet down the Gibraltar Ledges route during a search for two missing climbers.

Chris Hartonas and Raymond Vakili had disappeared November 5 in severe weather while climbing to Camp Muir, at 10,000 feet on the mountain's south side. In all likelihood they were dead by the time the weather cleared ten days later. On the morning of the fifteenth, the rangers spent hours digging out Camp Muir. As the storm cleared, the sky turned blue—irrepressibly, incandescently blue. Mike remembers the light as bizarre, strangely eerie.

The glazing is what Asha remembers: "a sparkling ice world." It had

Right: *A climber takes care on the rotten rock atop Little Tahoma.*

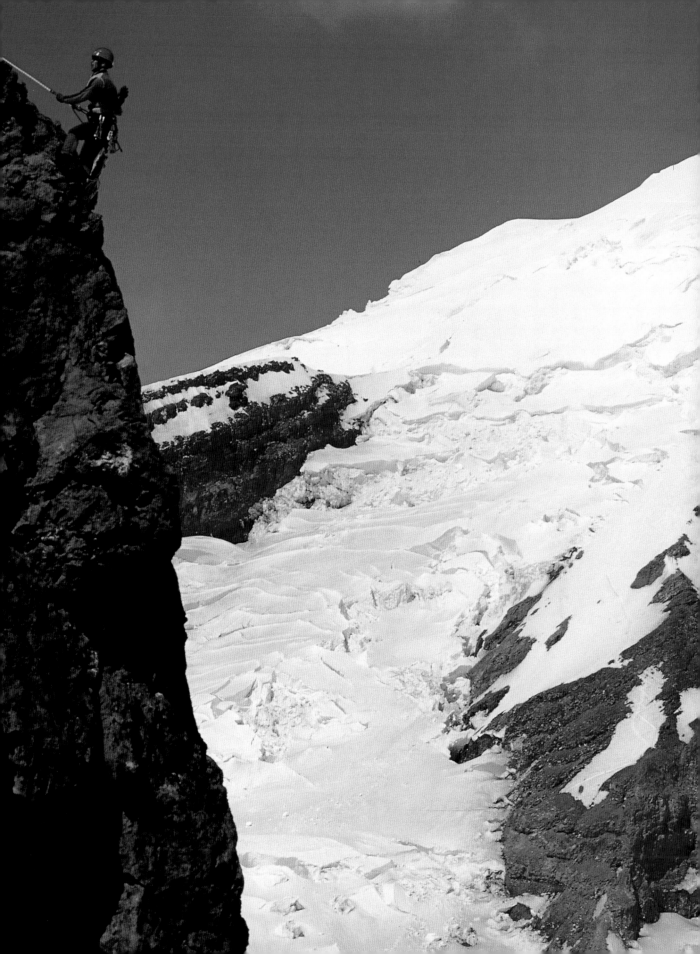

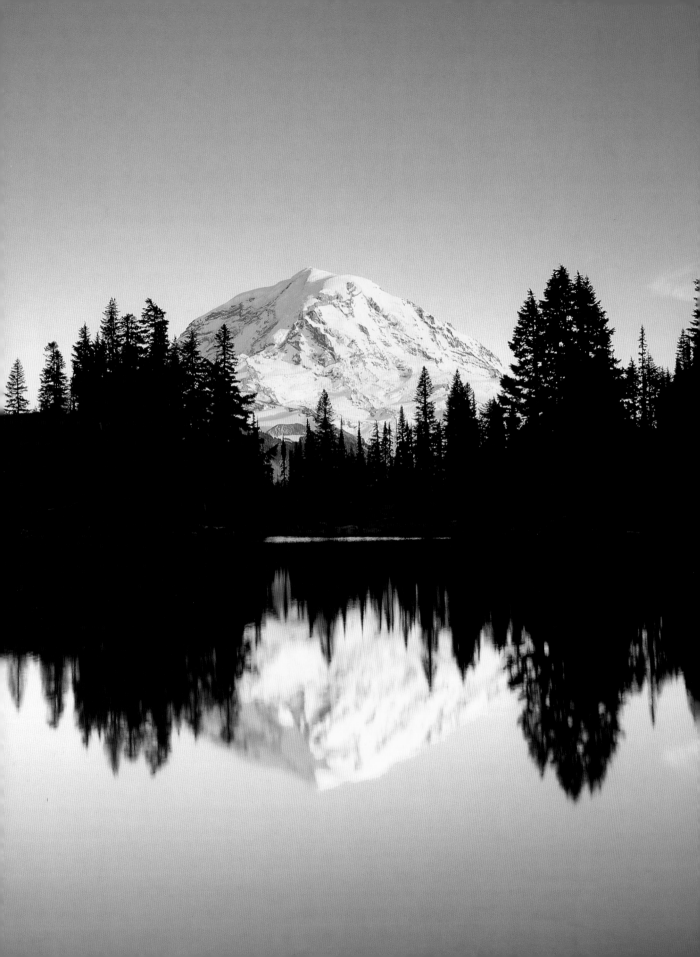

rained on the upper mountain, and the hulk had frozen into a massive crystal sculpture. Still, with the storm cycle finally broken, the time had come to find the missing climbers—not that searchers hadn't been trying during the storm, but now they had hope. A Chinook helicopter dropped three rangers and two Rainier Mountaineering Inc. (RMI) climbing guides above Camp Muir. They fanned out across the glacier, poking into crevasses, peering behind rocks. Asha had climbed the mountain many times in her young life, often with her father, a veteran Northwest mountaineer. She was comfortable on any kind of snow and glacier ice, but she was not a technical climber familiar with the hard ice of frozen rain. This beautiful but unforgiving world, like a steeply tilted skating rink, made her nervous.

Joe Puryear, a climbing ranger, looked up at the steeper slopes above and called out that if anyone didn't feel comfortable with the situation, they should go down. Asha hesitated. Art Rausch, an RMI guide, asked her if she wanted to rope up with him. Greatly relieved, she tied into the middle while Rausch and Ashley Garmin, also a guide, hitched into opposite ends.

"I don't know what happened," Asha recalled, "I just remember sliding." When her accelerating body pulled the rope tight, the guides peeled off as well. They tried to stop the fall by digging their axes into the ice, but their tools merely skipped against the hard surface. Asha was "totally screaming" when she lost her own axe and started cartwheeling. "I saw the instant I was going to die. I thought about my family, my best friends, then it was too much" and she just let her mind go as she felt her body start breaking. First one ankle, then the other, then a rib, then she felt her back crunch. She doesn't know how her foot broke inside her boot, but it did. And then after six hundred feet the slope tapered off and all three rescuers came to a stop, not far above an impossible drop. Asha lay quietly at first, but as she was loaded onto the helicopter the pain set in: "I could hear my voice screaming like I was disembodied." And finally, as her muscles racked in spasms, the morphine mercifully kicked in.

Miraculously, Rausch, who was thirty-eight, walked away with bruises. Garmin, forty-one, suffered head lacerations and a broken back. They both eventually returned to guiding on Rainier. And Asha hopes that her reconstructed ankle bones will one day heal well enough to allow her to ski and snowboard again. The missing climbers were never found.

Left: *Eunice Lake is a worthy objective for an afternoon hike from Mowich Lake. A fire lookout a few hundred feet above the lake affords a 360-degree view.*

Following page: *Life re-establishes itself shortly after a glacier retreats. Mount Adams looms on the horizon.*

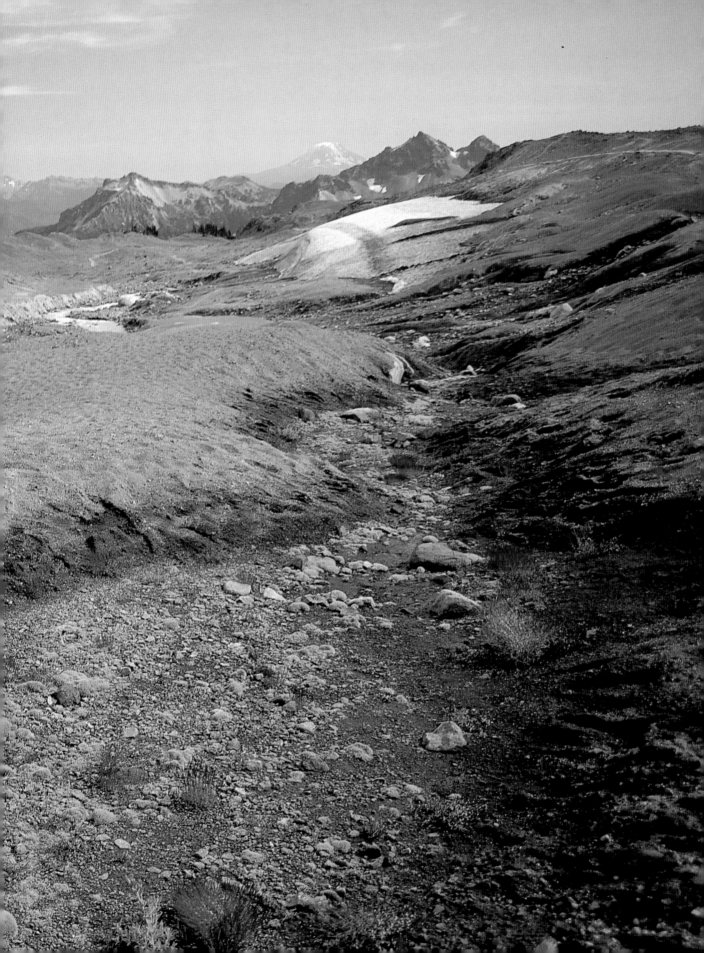

The conversation on Mike's couch died briefly as we came to terms with
Asha's story. But these rangers have seen way too much to pause for long.
David spoke up first to say that it was, in fact, a similar incident in 1995

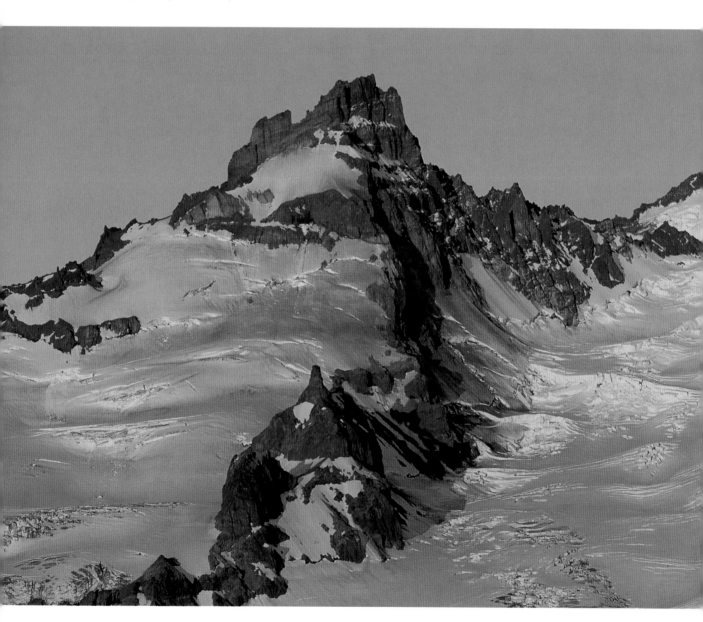

that changed life as they'd known it for Mount Rainier climbing rangers. That was the year that a young climbing ranger and a volunteer, both close friends of Mike's, died during the middle of an icy night while ascending the Emmons Glacier toward climbers in distress. Mike's friends never reached the climbers, and no one knows exactly what happened, but the two men's broken bodies were found 2,200 feet below the point of last radio contact. Until then rescue training had been haphazard; climbing rangers often were simply backcountry rangers with little mountain experience who had been promoted to higher altitudes. It was a recipe for disaster, and when the worst struck, Mike decided to do something about it. No one gave him the authority. Mike just figured a change had to be made, and he made it.

"Mount Rainier is *the* climbing destination for mountaineering in continental America," Mike said. "If someone is a mountaineer in this country, sooner or later they're going to come here." The climbing rangers needed to be of a similar caliber, up to the challenges of a mountain with the biggest glaciers south of Canada and with some of the worst weather in the world. The rangers also needed to be passionate for Rainier, able to work with visitors to inspire in them the same enthusiasm and respect for the mountain as the rangers themselves felt.

The success of Mike's new corps of highly trained rangers, according to David, has a lot to do with his policy of hiring only climbers with a strong familiarity with glaciers, a knowledge pool that tends to favor native Northwesterners. Mike also seems to have an uncanny ability to see through the personal eccentricities that climbers are notorious for. As David put it, "Good climbers have trips—unique needs, strange baggage." David's huge shaggy beard and vegan ways, Stefan's fondness for rangering in a kilt, Chad's run-ins with park rangers in Yosemite while soloing big walls: These are but curiosities to Mike, who, no stranger to eccentricity himself, had begun to hop around the living room floor while barking like a dog. David ignored the odd distraction while making his point that inside these self-motivated, cussedly independent climbers—beneath the surface, deeper than most managers are willing to look—are mountain athletes capable of earning the respect of their fellow climbers. And of pulling climbers out of trouble time and again. Mike stopped barking long enough to return a few compliments. "You wouldn't believe how many positive letters the park gets about this guy," Mike said, pointing at his shaggy friend. "People just *love* him." "No," David said, "*you're* The Shit." (That's a compliment.)

Left: *Although merely a spur of Rainier, Little Tahoma is the third highest peak in the Cascade Range.*

Following page: *Mystic Lake mirrors the north wall of Rainier.*

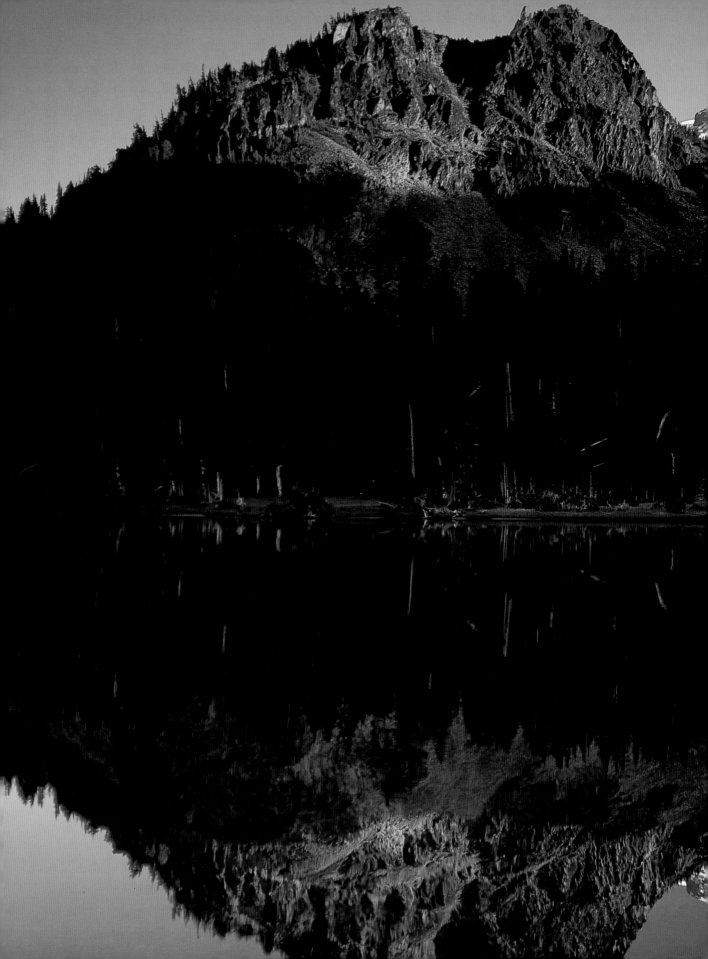

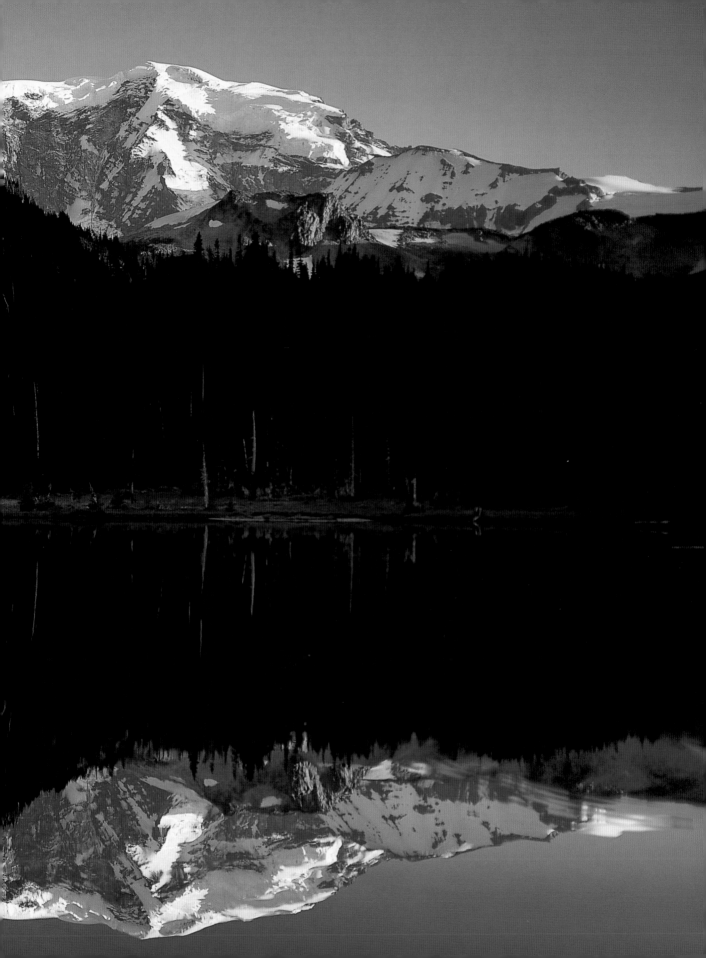

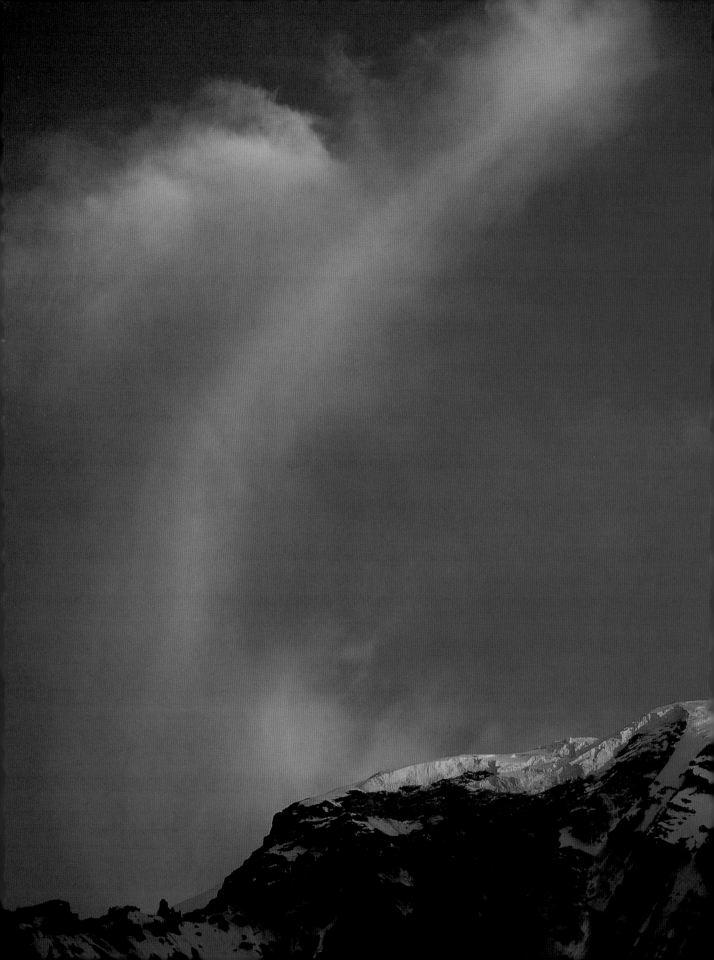

To prove his point, David recalled a night at Camp Schurman. Mike plopped onto the couch, chuckling, caught up by the memory.

That night they had both descended to Camp Schurman from the summit, dead tired. Mike had just climbed the mountain his thirty-sixth time that summer, the eighth time in the last seven days, the second time in this twenty-four-hour period. He fairly staggered off the glacier, only to notice that the light was on in the rescue hut. The door had been broken open and three strangers were inside; one was wearing Mike's uniform, another was trying to pry open the rescue cache with his ice axe. Mike, who is six-foot-one, and David, six-foot-three, walked in and said, simply, "Everybody out." No matter how tolerant they try to be in their jobs, catching people breaking into a search-and-rescue cache was too much. The rangers steamed for a minute. "It was a totally bizarre situation," Mike recalled. "Then David and I looked each other in the eye and started laughing." The rangers assessed the scene in a new light. Two of the vandals were a father and son. All were wearing cutoff jeans and they had a tent that looked like it was bought at Kmart. They were from a small town in rural Washington, and Mike worried that these guys might already hate the government; there seemed nothing to be gained from throwing the book at them. So he called them back in and asked pardon for his rudeness.

The next morning, the three vandals apologized profusely to the rangers. They offered to repair damage and to clean up any mess they had created. These same three now show up yearly, but instead of making trouble they help the climbing rangers with projects, they bring food treats to high camp, and they observe all regulations. That's how Mike and his team operate: by education, by being there for "the resource," by believing that a ranger's job is to serve, not to be served. "What I can't stand," said Mike, "is the attitude of rangers who resent it when the park is busy. The public is paying your salary, I tell them, and it's *their* park."

Though each member of the climbing ranger team is a highly skilled mountaineer, skier, snowboarder, and/or all-around alpine athlete who can keep a level head in the most frightening of situations, "it's the training that makes the difference," according to Mike. He drills them under stressful conditions, ratchets up the strain with a ticking stopwatch, and finally

Left: *A swirling cloud glows with the day's last light.*

Following page: *Seracs fracture and tumble as the Carbon Glacier flows over a steep step.*

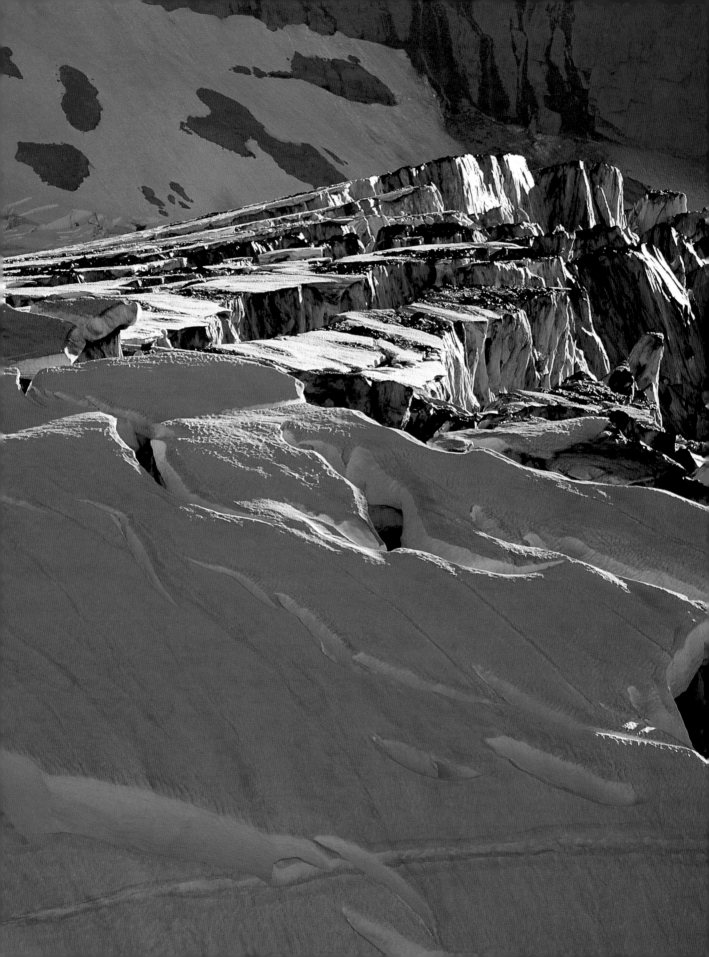

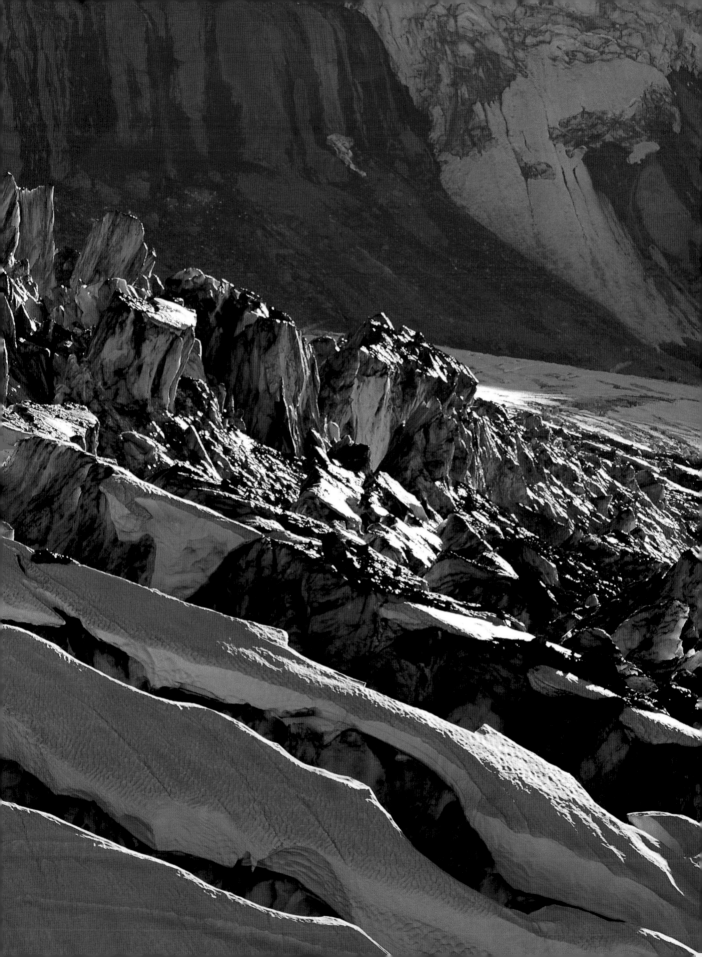

blows the whistle at unpredictable intervals. When the whistle sounds, everyone is supposed to let go of the rope system—it's as if an avalanche has swept through and the rescuers are suddenly fighting for their own lives instead of for someone else's. If the knots and other safety systems aren't set up properly, someone dies.

The rangers do their litter training from a bridge over Box Canyon, a skinny two-hundred-foot-deep slice in the rock with a bellowing torrent beneath. The tight rock walls, the roar of the river, the dizzying drop off the edge of the bridge, all have the intended disconcerting effect. And then comes the whistle, and everyone lets go. The idea of this training is that when the real thing happens on the mountain, no one needs to think about how to set up Z-pulleys or other technical details. Such things have become automatic, like driving a car. The ranger's frontal lobes are free for the critical functions unique to each rescue: surveying the scene, assessing the danger, setting up anchors, ordering panicked climbers where to go and what to do.

On June 11, 1998, Mike was on the summit. It was his day off, and he was just about to strap into his snowboard for a ride down the Emmons Glacier when his radio crackled. An avalanche had swept ten people over a cliff on Disappointment Cleaver, south of Mike's intended descent route. He swiveled his board and twenty minutes later was on the scene, leading RMI guides in the rescue. Guides and clients had been carried over the cliff, but others were above the slide and available to help. Victims were hanging in space by ropes frayed to the core. One guide, himself avalanched, clutched a rope in his broken hand; three clients hung from the cord. Mike ordered pulley systems set up. Called for helicopters. Orchestrated twenty people, some in serious pain, in a steep, avalanche-prone, loose-rock–infested, cliff-studded environment. And everyone was off the mountain by sunset. One man, who had been hanging in space under a waterfall of melting snow, died of hypothermia. There could have been many more deaths.

The Cleaver disaster and the near storybook rescue played huge in Washington's media. But it was another rescue, less than a week later, that Mike is particularly proud of. He's proud because his team, working in perfect precision, pulled a severely injured victim off the remote Liberty Ridge in exactly four hours, round-trip. And the media barely paid it any attention.

The call came in during the middle of the night of June 16. A climber

Right: *Ice adopts all sorts of odd forms high on the mountain. Sun and wind shape isolated blocks discharged by the moving ice.*

Following page: *A light snowfall flocks the evergreens like wild Christmas trees.*

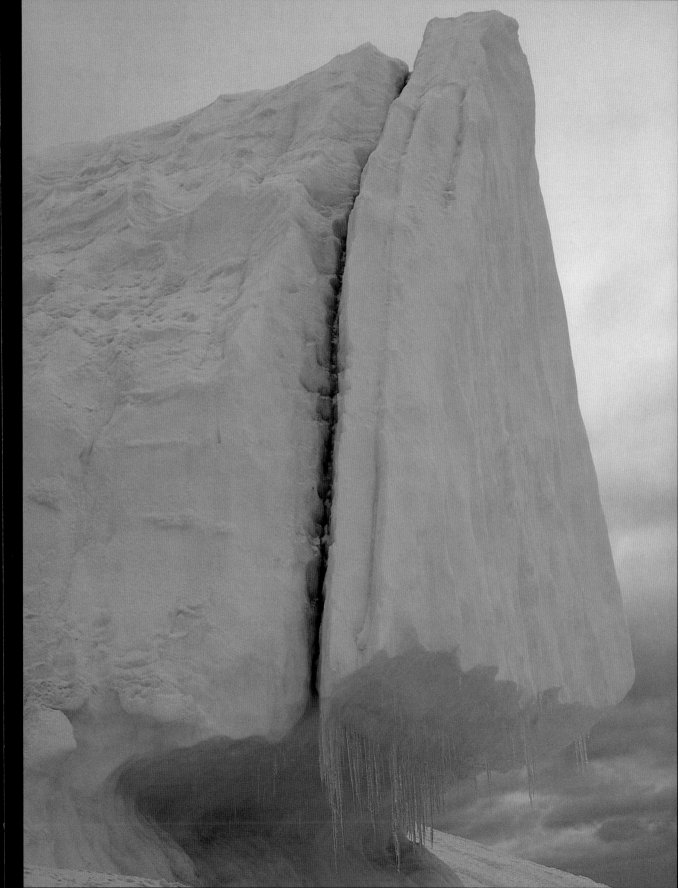

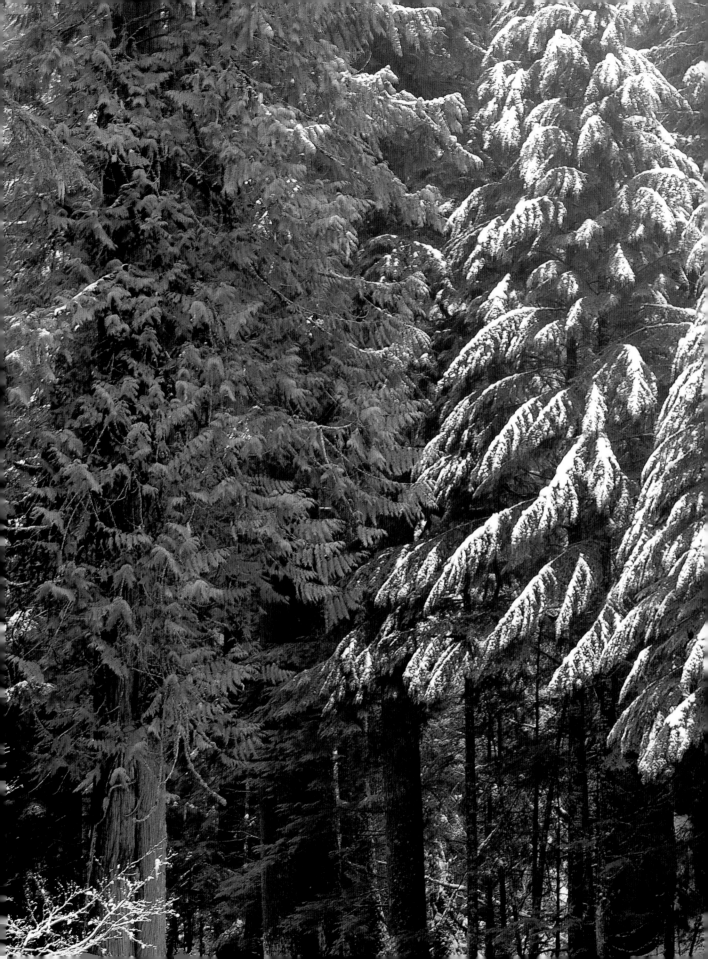

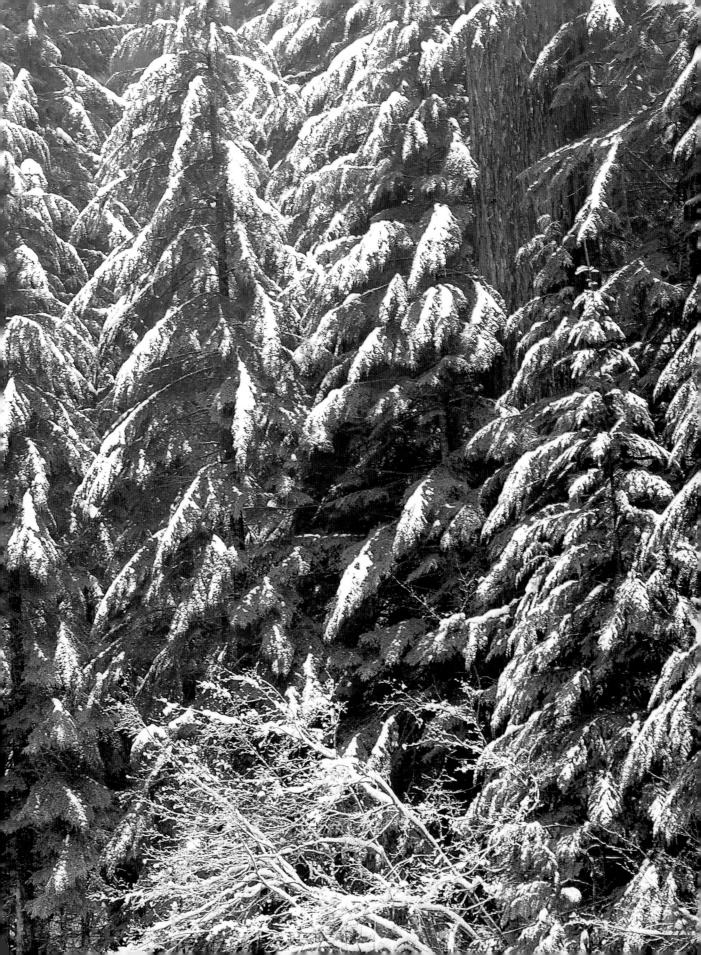

had hiked out ten miles to report that one of his two partners, sixty-year-old Malcolm Talbot, had broken his leg badly during a 200-foot fall at the 10,000-foot level on the ridge. Mike had recently climbed the route, and he could imagine the situation. Immediately he formulated a plan, then he pulled his people together. Eight rescuers choppered to the 8,000-foot level of the Carbon Glacier, right at the toe of the ridge. Four rangers scrambled 1,000 feet up the technical ridge, carrying a litter and 1,800 feet of rope. Four stood by in case something went wrong. The climbing rangers reached Talbot and his partner, splinted the leg, placed him in the litter, and lowered him 900 feet down 40- to 60-degree ice. Rocks whizzed by; hanging glaciers threatened from above. It was an unnerving situation, with tricky knots to pass through the lowering system, but the rangers had trained extensively that year and everything came off without a hitch. In a morning's work, the show was over. That's what makes these rangers proud.

But it doesn't mean they like it. A stint of five rescues in four days in

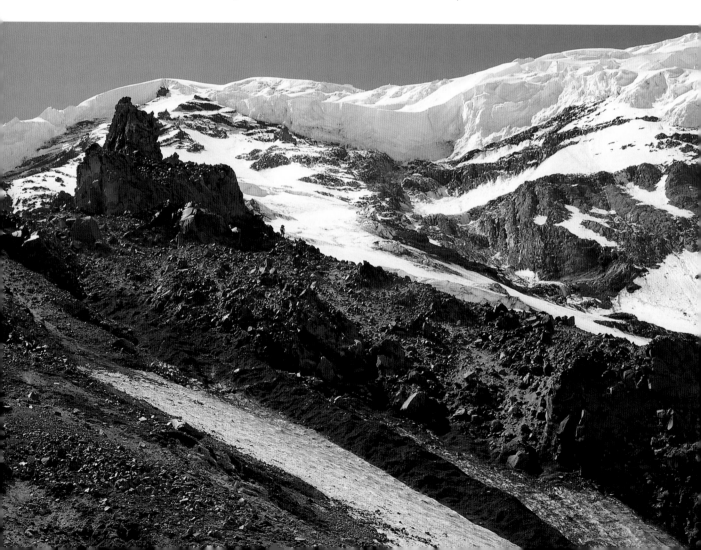

1998 really got to them. On the third of those sorties, David had to crawl into extreme winds during a ground blizzard at 13,600 feet to assist traumatized and hypothermic climbers who had fallen into a crevasse while traversing from the top of the Liberty Ridge to the Emmons Glacier. David lost the tip of his own nose to frostbite. I winced, thinking of my own partner's fall into a crevasse at almost the same spot.

In fact, all of 1998 was over the top, much like 1999. "That's not the way I want to live my life," David said, "to have to go day after day." Much preferred are what the rangers call "preventative" rescues where early intercession saves the day before the climbers know their day needs saving. These catalysts to safety happen at every step of the way, from the right advice at the ranger station near the parking lot, to providing a suffering climber with the face-saving excuse he needs to go down.

People sometimes make stupid choices under the grip of summit fever. "I once had to talk a wife into staying with her husband," Mike recalled incredulously. "All the rest of his friends had ditched him because he was too slow, and she was about to leave him behind, too." It's called "bagging," where you leave the one who can't keep up sitting by himself in a sleeping bag while the rest go on. Of course, the climbers *plan* to pick up their bagged partner on the way down. Trouble is, sometimes bad weather rolls in, or the guy has an altitude illness. "The mountains push people into situations they're not comfortable with," Mike said, "and they tend to slip into a selfish three-year-old's mode." Rangers talk to people about the meaning of what they're doing—tell them that this betrayal of trust could have a long-term effect on a relationship.

The rangers on Mike's crew are big on partnerships. Even though many climb solo at times, when they have a ropemate they're totally committed to the team. "That's why I like the term 'mountaineer' better than 'climber,'" Mike said. "As I see it, mountaineering is about human relationships in this environment. The single most important decision you'll make is who you choose as a partner." Can you count on your buddy when the chips are down?

Consider two climbers who descended the Paradise Glacier on April 11, 1999, unroped despite a blanket of crevasse-hiding snow. They both broke through a snow bridge, but one climber's pack caught on the edge and he

Left: *A climber negotiates a rubble field below Thumb Rock camp on Liberty Ridge.*

Following page: *Plants exposed on high ridges in the alpine zone hug the earth to avoid the full force of the wind.*

managed to pull himself out as his partner plunged into the terrifying hole. The safe one knew what to do. He set up an anchor, attached the rope, and lowered it over the edge. Trouble was, the man below was in a jam, quite literally, and couldn't grab the rope. So the safe one called 911 on his cell phone. When Mike and his partner Tom arrived two and a half hours later, they looked into the hole and then asked the safe one why he hadn't rappelled inside to help his partner. The gist of it: "Too scary."

Well, it *was* scary. Mike rappelled eighty feet before he reached the victim, then spent an hour, much of it upside down, working with the severely hypothermic climber, who was dangling by his armpits from the straps of his wedged pack. The man had lost all circulation to his arms and could do nothing more than press his legs against the icy walls to keep from slipping out of his pack straps and dropping who knows how much farther. After tying the victim to a rope, then cutting the pack free with a knife, Mike climbed his own rope, pushing the injured climber from below as the pre-set Z-pulley system was employed from above. Together they lifted the climber back to the world of the living.

Below: *Ice caves once formed near the toe of Paradise Glacier. Too little snow accumulates today for the caves to form again.*

Right: *Mosses and ferns glisten with waterfall mist along the Ohanapecosh River.*

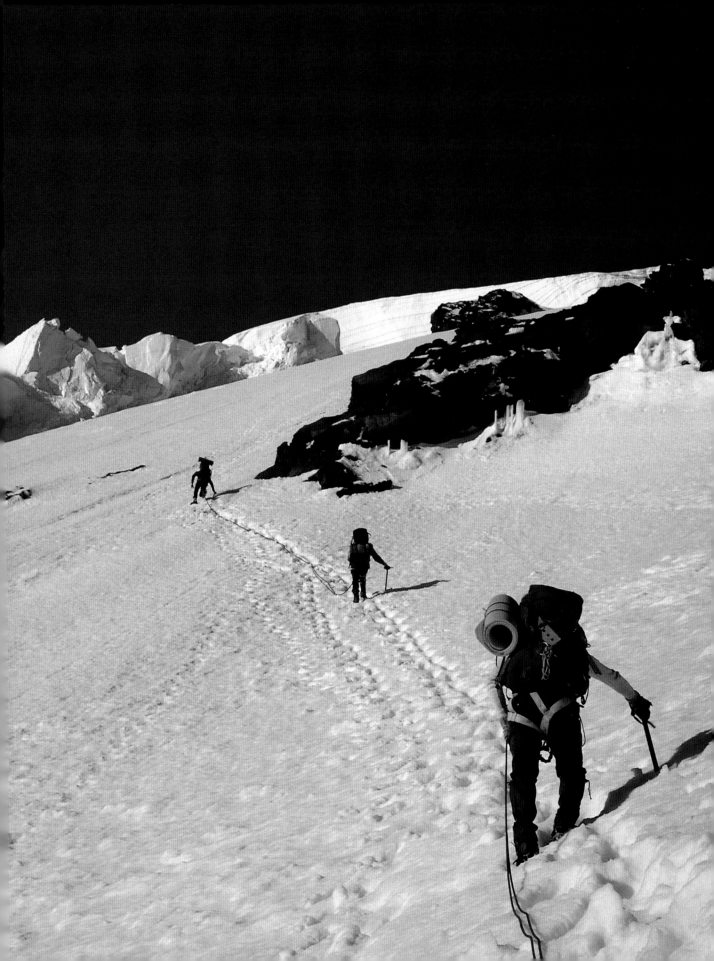

Sitting on his living room couch, Mike didn't quite say the words, but his gaze was perfectly clear: "Would you want to climb with someone who indulges his insecurity instead of doing everything he possibly can for his partner?"

—————

Left: *Climbers on the snowfield above Thumb Rock on Liberty Ridge.*

Below: *June in the Tatoosh Range means snow camping.*

The rangers have other peeves, too. Tops on that list are people who treat Rainier as nothing more than a giant Stairmaster-in-the-sky or, worse yet, as a summit-register-to-sign before checking the peak off their life list. The most weirdly frustrating part of their jobs: reminding climbers how beautiful the mountain is. According to the rangers, the ultimate way to experience the mountain is to start hiking in the old growth at 2,800 feet, then watch the incredible transformations around you as the trail takes you ever higher, step by step, through moss-draped rain forest, into subalpine meadows, over terminal moraines, across heavily cracked ice fields, up steepening snowfields, until eventually you reach the summit plateau some 11,000 feet above the trailhead. This is how to make the mountain a part of your being, and you a part of its. The rangers' greatest satisfaction comes from helping

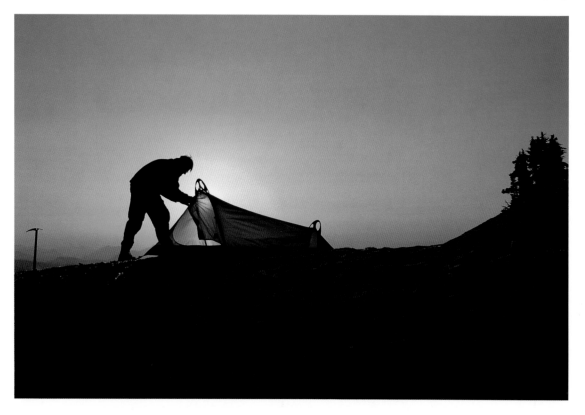

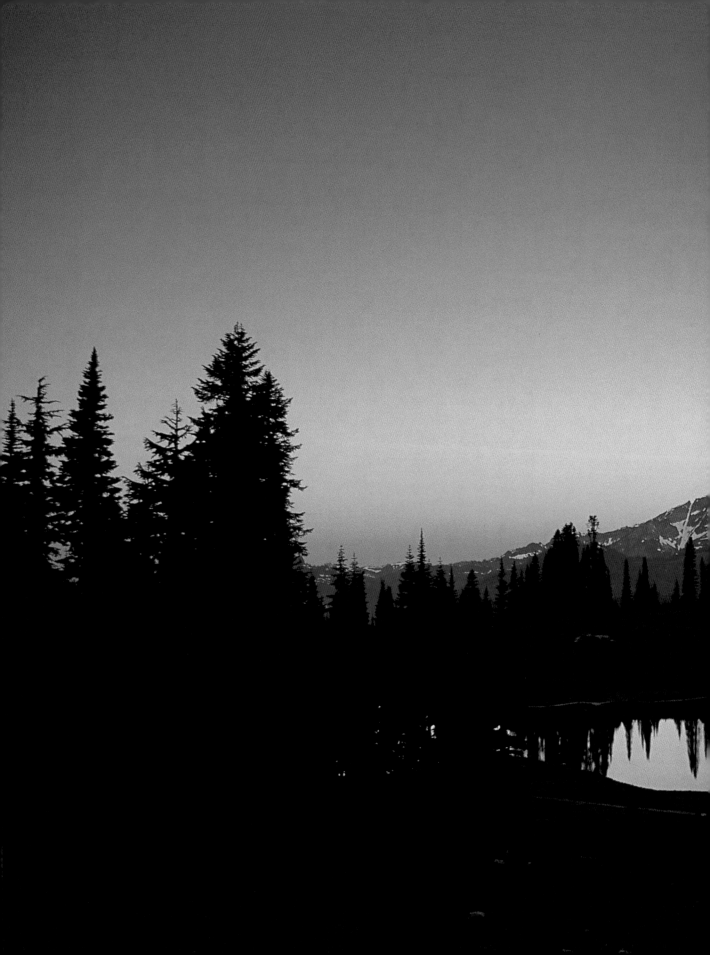

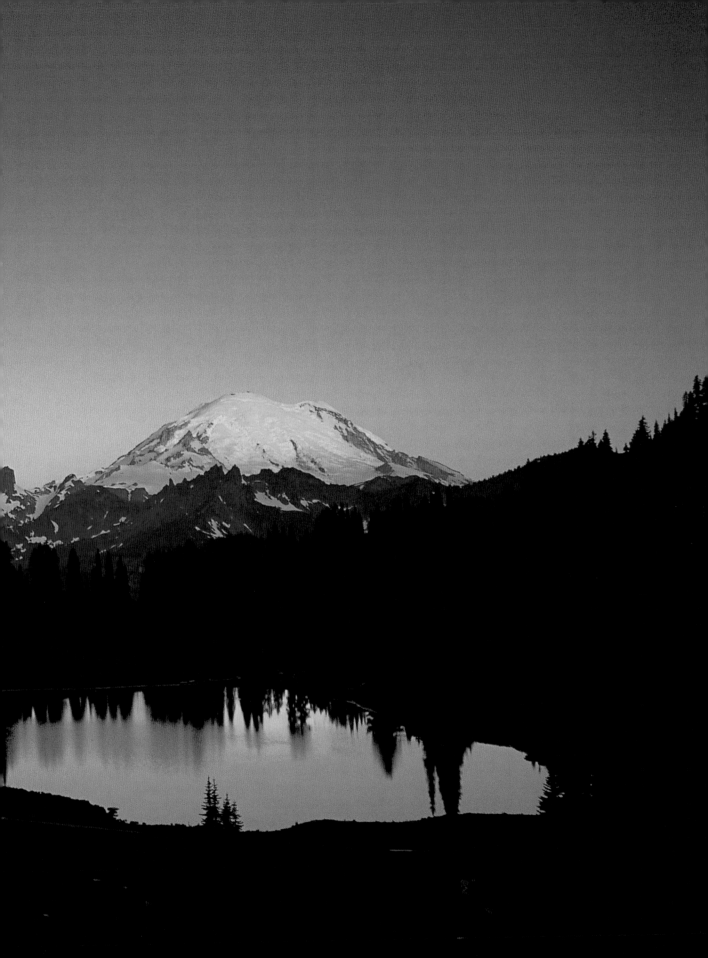

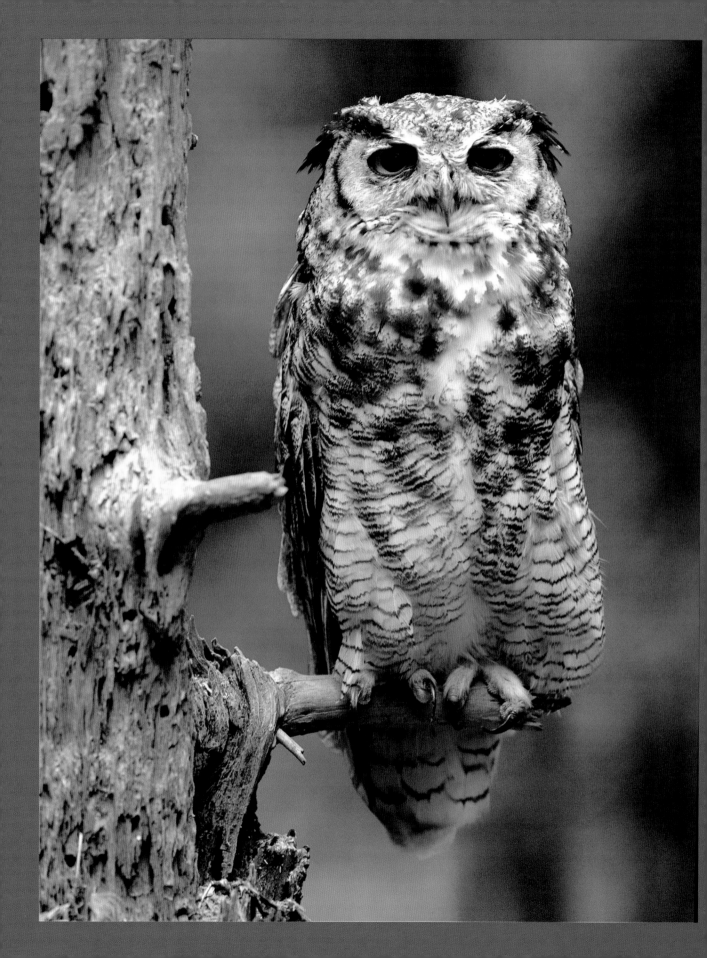

"climbers" to become "mountaineers" who are spiritually—not just physically—connected to their ropemates and to the mountain.

When Mike hears climbers complain about the crowds on Rainier, he can only shake his head and drop into his pedantic mode. Thirty-nine climbing routes plus numerous variations trace their lines up the peak, offering several lifetimes' worth of challenges. A plethora of high camps provide options for solitude. Fewer than ten of the routes are likely to hold any climbers at all on a given day, while only four of these receive the brunt of the load—the Emmons Glacier, the Disappointment Cleaver, the Kautz Glacier, and, for the most experienced climbers, the Liberty Ridge. The rest of the mountain? Empty, more than 99 percent of the time. Crowds on Rainier? Only for those who enjoy the company—or who are too dull or intimidated to avoid it.

There are other ways, too, to enjoy these glaciers. "You want to know something unique about Mike's ranger program?" asked David. "Years ago he recognized that snow sports are an increasingly important part of this mountain. I came to climbing as a snowboarder, and you see more and more of us up high." The snowfield between Camp Muir and Paradise has become popular with skiers and boarders. More serious mountain skiers usually take the Emmons Glacier and slide off the summit, or launch from the huge crevasse near the top, depending on conditions. The fact that most of the rangers are powerful skiers and boarders who shred the mountain both on and off duty earns them tremendous respect from young riders. But it's not just that, said David: "It's that Mike has recognized boards as a tool for search and rescue. No one else in the park service would have seen that potential." Their skis and boards let the rangers cover the mountain much faster than they could on foot, at least when the mountain is in good condition.

Skiing is also dangerous. Defy the conditions, or make a simple mistake in the wrong place, and suddenly you're cartwheeling down the mountain. On low-angle routes like the Emmons Glacier or the Paradise Glacier below Camp Muir, you'll soon come to a stop unless the mountain is icy. But on a steep route like the Liberty Ridge, skiing is a different story. If there's one mountain memory that brings a shudder to these rangers, it's that of the Swedish telemark skier David Persson.

On the evening of May 24, 1999, Persson's ski partner called on his cell

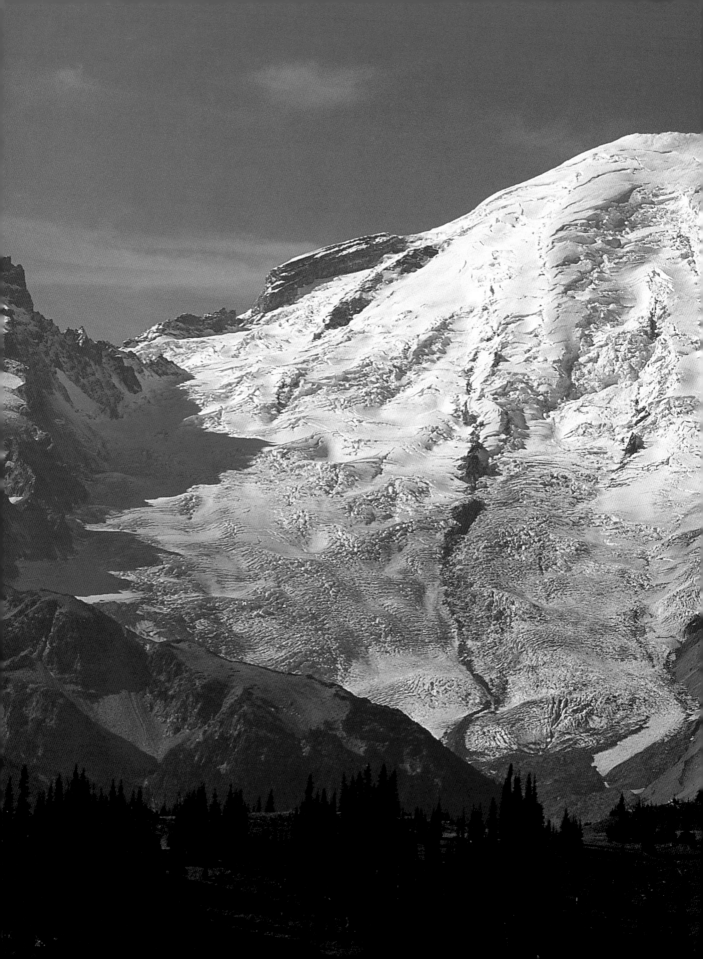

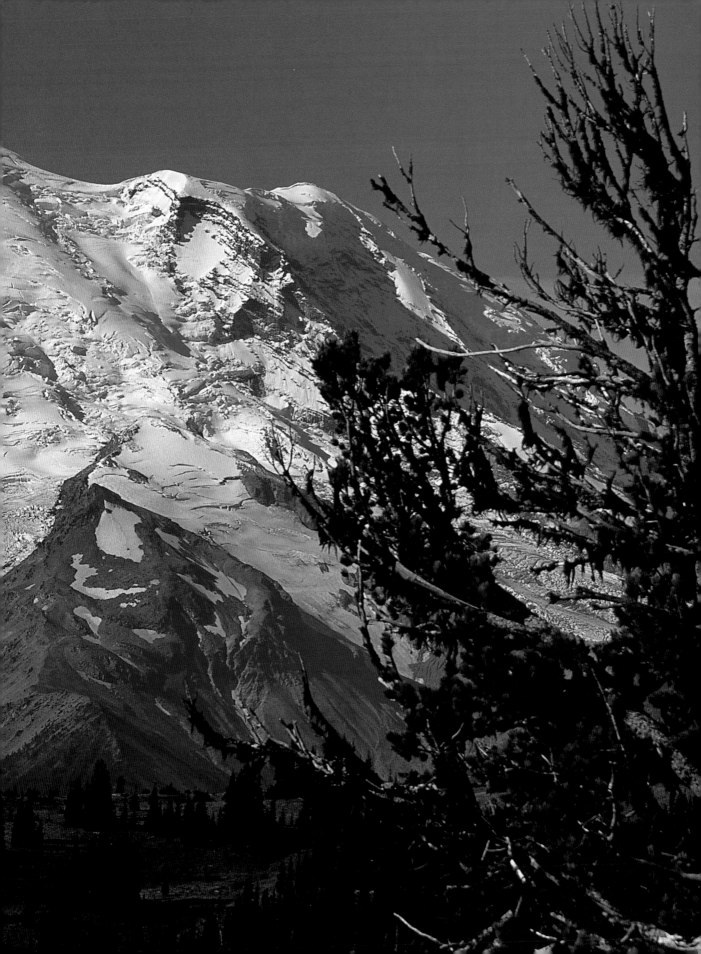

phone from Thumb Rock, halfway up the Liberty Ridge. He reported that Persson had lost an edge on an icy patch near the Black Pyramid, a 50- to 60-degree section near the top of the ridge. Persson had skied the route in its entirety the day before, and he had gone back to do it again, this time with a partner. The partner examined the upper ridge's unrelenting steepness and decided it was too scary to ski. Persson clipped into his bindings anyway and slid onto the steep slope. Then something happened, and suddenly Persson was out of control, tumbling down the Willis Wall side of the ridge. His partner saw him disappear over the edge, then nothing.

The next morning Mike and ranger Debbie Brenchley climbed onto Doug Uttecht's Bell Jet Ranger helicopter and flew reconnaissance. They spotted the body at the 9,800-foot level of the Carbon Glacier, immediately under a rarely climbed route called Thermogenesis that's notorious as an avalanche chute for calving ice cliffs above. No sooner did they spot Persson's remains than a tremendous avalanche thundered down the gully, burying the body. The afternoon's warming conditions made the place entirely too dangerous, and Mike told Uttecht to fly them home. They'd return in the relative safety of dawn, if they'd return at all.

Mike asked three rangers—Chris Olson, Dee Patterson, David Gottlieb—if they wanted to go in to the site. There was no one to rescue; this would just be a body recovery. But the rangers knew how important the remains are to the family. "I have letters all over my desk from family members who are grateful for the return of a dead son or husband," Mike said. "The body is so important for closure." Mike's plan was to fly in with two helicopters, one to place rangers on the ground, and the other to fly high and monitor the icefall above, radioing down at the first sign of an avalanche. Mike placed David in the second helicopter, wanting his own main climbing partner prepared to get *him*, should that become necessary. They would fly before dawn. But that night everyone drove to Mama's Mexican Kitchen in Seattle to drink margaritas in a vain effort to dispel the all-consuming tension. They would be flying into the most dangerous spot on Rainier, one of the most dangerous places in the mountain world, to pull out a dead person.

As the sun broke over the horizon, two helicopters were already flying in formation straight toward the dark north face where the Willis Wall waited. Glaciers glowed with the pink of alpenglow, and Mike felt the pounding chop of the blades like adrenaline pulsing through his veins. "But adrenaline, testosterone, and helicopters are typical on rescues," he said. "This

Previous page: The Emmons Glacier, seen here from Sunrise, is the largest on the mountain.

Left: *The Colonnades, volcanic basalt formations, testify to the origins of Mount Rainier.*

morning was more than that. It was wildly surreal. Imagine the scene: a landscape so extreme and so beautiful. The serenity of sunrise, yet the gravity of a body recovery mission. And there was an understanding among the rescuers: we shared a commonality with Persson. We recognized his mountain passion, yet saw our own mortality in his dead body. There were so many emotions in those two helicopters throbbing into the sunrise. Powerful visions, gross realizations, deep understandings, all were running full speed."

Where Persson's body had been, only a streak of blood remained. Instead of being able to dash in, grab the body, and fly out to minimize the avalanche danger, Mike and Chris had to wallow in waist-deep pits of bloody snow while digging for the fallen skier. Persson had rag-dolled 2,500 feet and an artery must have opened, because blood was everywhere. Yesterday's avalanche, and maybe more since then, had pushed the body one hundred feet farther down the mountain, and it took an hour of nerve-wracking digging along the trail of blood with the constant threat of avalanches before they found it. Having gone beyond rigor mortis, the body was limp. A broken bone projected through the pants. Normally the rangers are careful to bag a body before bringing it onto the helicopter, but in this case the danger was too high and they just had to drag it on board and fly it out.

Mike remembers looking at the highly muscular body of this thirty-one-year-old man who had loved doing exactly what Mike and his friends found so rewarding in their own lives. Persson, whom he'd never met, looked like his own athletic mountain companions. Later, behind the wheel of his car, the tears started flowing.

The park management knew how dangerous the recovery would be. Later on, others would throw accusations of hot-shotting. Sure, the rangers had proven their mettle over and over again during the previous years, but this time some felt they had gone too far, risked too much merely to bring home a corpse. What's more, by the reckoning of many, Persson was a reckless adventurer who had brought his fate upon himself.

"But all we wanted to do was the right thing," Mike said. "We knew the family needed the body for their grieving. We brought him back out of respect for the man."

And if there is anything I took away from my days with three of Mount Rainier's climbing rangers, it's a powerful sense of respect, and gratitude, for the passion they extend to their fellow climbers and to the mountain they serve.

Right: *Saint Andrew's Lake is one of the jewels of the Wonderland Trail.*

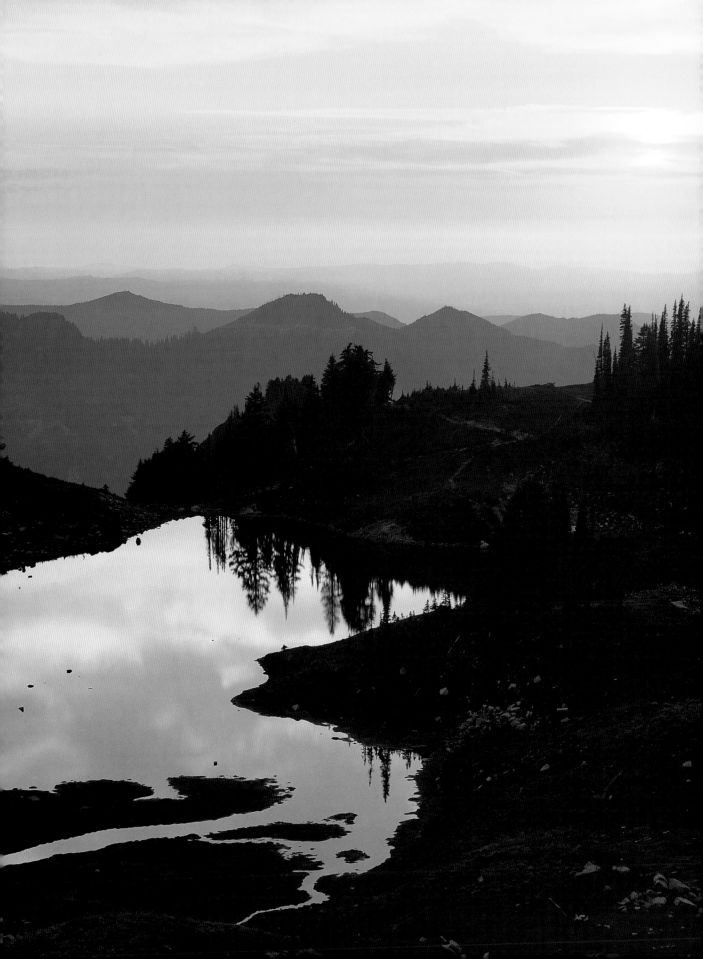

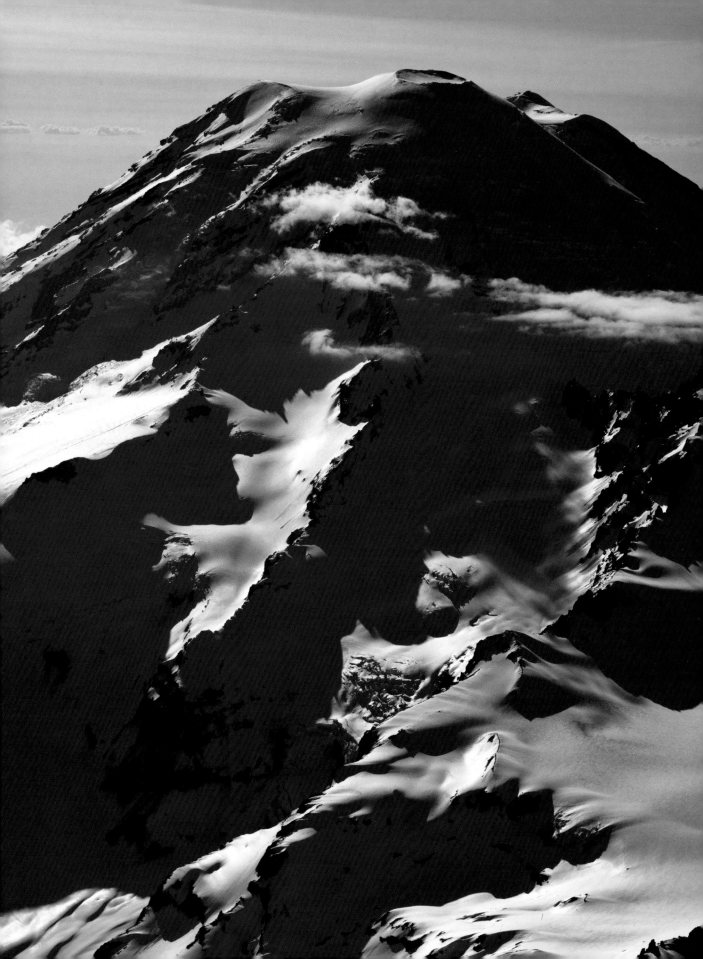

Photography Notes

I use all sorts of photographic techniques when I shoot for stock agencies: cross processing, color infrared film, blurs, colored filters. The images are not representational. The rules are different here. I tried to capture the form and the spirit of Mount Rainier without enhancement.

To achieve that end, I used a spartan kit. Most of the images were created with a Mamiya 7 medium format rangefinder camera and one of two lenses. The 7 is not an easy camera to use. As a rangefinder, what you see is not necessarily what you get. Because you frame and focus through the lens, you can't see the effect of a polarizer or the best place to put a graduated neutral density filter. The in-camera light meter doesn't take light fall-off from the filters into account. Mamiya made only four lenses for the body (they recently added a longer telephoto), and I owned three of them. The widest lens is wider than the viewfinder so a second viewfinder must be fixed to the camera body to frame the image while the photographer focuses and meters with the original one. The telephoto range was limited to the equivalent of a 75mm lens in 35mm format.

If your goal is to produce the sharpest and most grainless images in the wilderness, the 7 is worth the bother. First, the system is light enough for backpacking and climbing. The body is lighter than my pro model Canon and the leaf shutter lenses are no larger than their 35mm equivalents. Weight and bulk matter when carrying backpacking, climbing, and photo gear for several days.

Left: Aerial of Mount Rainier from the south with Little Tahoma on the right

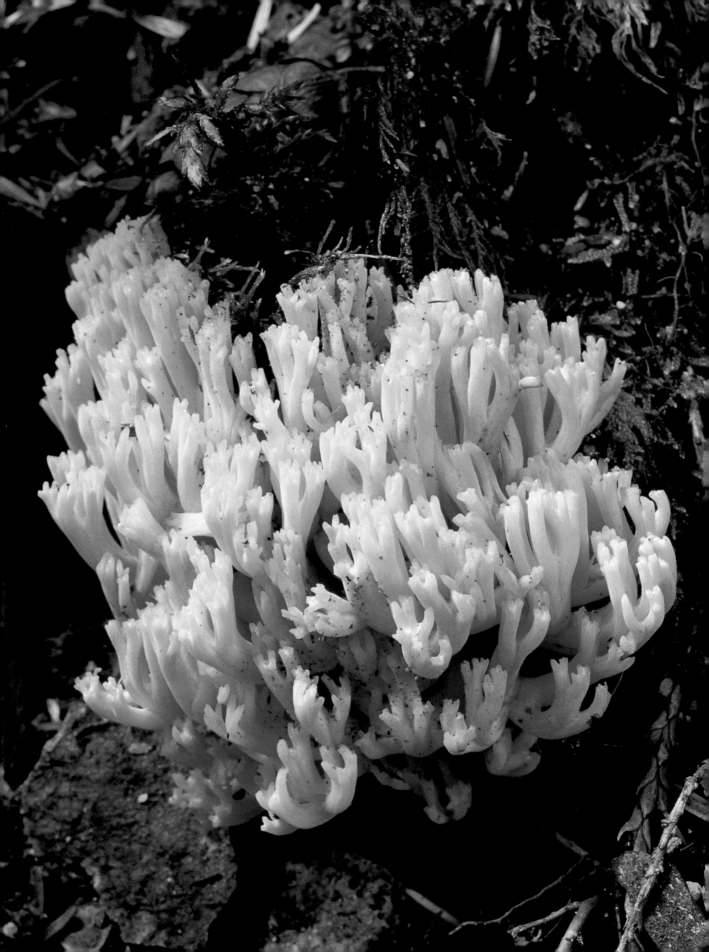

Rangefinders tend to produce sharper images than Single Lens Reflex cameras for two reasons. First, there is no mirror. In an SLR the mirror must sweep out of the way before the film is exposed. The "mirror slap" causes vibration that can translate to a slight blurring. Second, it's easier to make a sharp lens for a rangefinder because it is closer to the film plane. I confess that I don't understand the physics of that argument. I'm satisfied that the 7 produces the sharpest 6 x 7 cm images I've ever seen. Plus, medium format's larger image delivers less grain and sharper images when enlarged.

I used only two filters for this book. A polarizer removed glare from water, whether the surface of lakes or water droplets on leaves. It also darkened hazy skies. A graduated neutral density filter compensated for slide film's high contrast. When the eye looks at a sunset over a mountain lake, it can resolve all the tones, but slide film can record only five stops. If one exposes for the sky, the mountains turn black. The correct exposure for the lake and mountains will wash all the color from the sky. A graduated neutral density filter darkens the bright areas without shifting color, reducing contrast to a level the film can handle.

Since many compositions require long exposures, a tripod is mandatory. I use the smallest carbon fiber Gitzo and a small ballhead.

Fuji Velvia is still the gold standard for nature photographers. It's slow (I shoot it at ISO 40 instead of its rated 50), contrasty, and extra-saturated, but its grain-free presentation and rich greens make it a favorite. Kodachrome looks gray in comparison.

I chose 35mm for some shots. The 7 can't do true macro so I employed my Canon EOS system for close-ups. I carried a Contax G2 rangefinder on my climb of Little Tahoma. Its Zeiss lenses are the sharpest I've found in 35mm and it's a real featherweight. An Olympus OM-1 with a 28mm lens served on Liberty Ridge and the Disappointment Cleaver routes. It was my first decent camera.

In the interest of full disclosure, I should confess that the cougar kitten was a captive wildlife model. I doubt there is an equivalent shot of a wild kitten in the world. One would be lucky to get the shot and luckier to get out of the area alive.

Left: *Coral fungus thrives on the forest floor.*

SUGGESTED READING

Asars, Tami. *Hiking the Wonderland Trail*. Seattle: The Mountaineers Books, 2012.

Barcott, Bruce. *The Measure of a Mountain: Beauty and Terror on Mount Rainier*. Seattle: Sasquatch Books, 1997.

Beckey, Fred. *Cascade Alpine Guide, Vol. 1, Columbia River to Stevens Pass*, 3rd ed. Seattle: The Mountaineers Books, 2000.

Clark, Ella E. *Indian Legends of the Pacific Northwest*. Berkeley: University of California Press, 1953.

Filley, Bette. *The Big Fact Book About Mount Rainier: Fascinating Facts, Records, Lists, Topics, Characters and Stories*. Issaquah, WA.: Dunamis House, 1996.

———. *Discovering the Wonders of the Wonderland Trail Encircling Mount Rainier*, revised ed. Issaquah, WA.: Dunamis House, 1998.

Gauthier, Mike. *Mount Rainier: A Climbing Guide*, 2nd ed. Seattle: The Mountaineers Books, 2005.

Kearney, Alan. *Color Hiking Guide to Mount Rainier*. Portland: Frank Amato Publications, 1999.

Kirk, Ruth. *Sunrise to Paradise: The Story of Mount Rainier National Park*. Seattle: University of Washington Press, 1999.

McNulty, Tim, and O'Hara, Pat. *Washington's Mount Rainier National Park: A Centennial Celebration*. Seattle: The Mountaineers Books, 1998.

Molenaar, Dee. *The Challenge of Rainier*, 4th ed. Seattle: The Mountaineers Books, 2011.

Muir, John. *Mountaineering Essays*. Edited by Richard F. Fleck. Salt Lake City: University of Utah, 1997.

Nelson, Dan and Alan Bauer. *Day Hiking Mount Rainier: National Park Trails*. Seattle: The Mountaineers Books, 2008.

Nelson, Jim, and Potterfield, Peter. *Selected Climbs in the Cascades, Vol. 1*, 2nd ed. Seattle: The Mountaineers Books, 2003.

Right: *Bright red pillars of Indian paintbrush accent the flower fields of Paradise.*

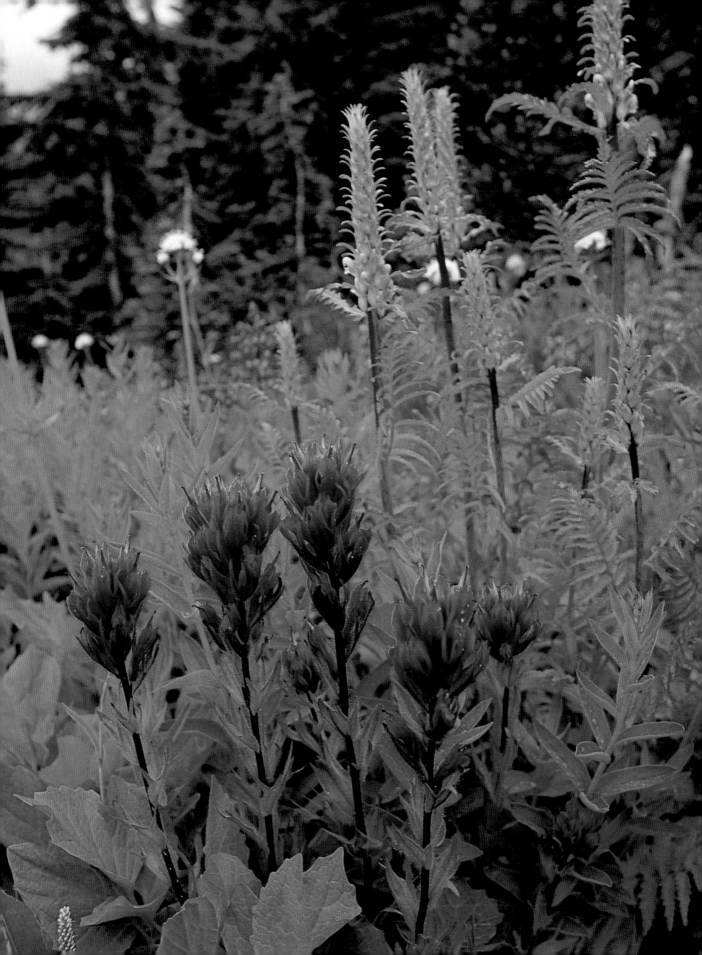

ABOUT THE PARK

Mount Rainier National Park
Star Route, Tahoma Woods
Ashford, Washington 98304
(360) 569-2211
www.nps.gov/mora

Established in 1899, Mount Rainier National Park is the fifth oldest national park in the country, encompassing more than 230,000 acres (365 square miles) of park land and wilderness. Old-growth forests, sub-alpine meadows, glaciers, and wild flora and fauna are all stunning features of the park, but its centerpiece is, of course, 14,410-foot Mount Rainier.

Mount Rainier is an active volcano, covered with more than 34 square miles of permanent snow and ice, making it the largest single peak glacial system in the contiguous United States. Rainier is also the tallest volcano and the fifth highest mountain in the country, excluding Alaska and Hawaii. Glaciers actually comprise about nine percent of the total park area and have a volume of about one cubic mile. The Emmons Glacier, at 4.3 square miles, has the largest surface area of any glacier in the contiguous United States, while the Carbon Glacier boasts being the longest (5.7 miles), thickest (700 feet), and having the lowest terminus at 3,500 feet above sea level. During the last ice age—approximately 25,000 to 15,000 years ago—glaciers covered most of the area that is now the park and even extended to Puget Sound. The volcano last erupted between 1820 and 1894.

The park is open year-round, but it is during the months of July and August when the lush sub-alpine meadows of Mount Rainier host an exhilarating display of more than 30 wildflower species—one of the biggest draws for many of the two million visitors who enter the park each year. Such meadows are found at elevations between 4,000 and 6,500 feet above sea level throughout the park, but the most popular are at Paradise.

While viewing wildflowers and hiking (there are 240 miles of maintained trails in the park) are the most popular activities, climbing tends to receive more public attention. The first recorded climb occurred in 1870 when four of five climbers reached the summit. More recently, about 10,000 people attempt to climb Rainier each year; for instance, in 2010, 10,500 climbers made the attempt, with less than half succeeding. Each year, on average, ten climbers are rescued at high altitudes at a cost of about $10,000 each time. (Several thousand pounds of human waste are also removed from the mountain twice yearly.) Permits are required for all climbing activities and to travel above 10,000 feet or on glaciers.

In 1997 Mount Rainier National Park was also designated a National Historic Landmark District for its representative National Park Service "rustic" style architecture from the 1920s and 1930s and early park planning.

Left: *Mostly nocturnal, this young porcupine ventured out in daylight.*

James Martin

In the last three decades, photographer Jim Martin has climbed in Africa; hiked across South Georgia Island; worked with photographer Art Wolfe on books and projects; beat cancer; had a wild orangutan crawl into his arms; watched an orca swim twenty feet below him; written ten children's books on natural history as well as the first scientific work in English on chameleons; hiked with Gary Snyder and climbed with Jon Krakauer; and petted a wild Komodo dragon. "My life has no thread to it," Martin explains, "except the stubborn determination to do what I want." He has been exclusively a photographer and writer since 1989, publishing in magazines including *Smithsonian*, *Outside*, *Climbing*, *Sports Illustrated*, *Backpacker*, and *Outdoor Photographer*; recent books include *Planet Ice*, *North Cascades Crest*, *Digital Photography Outdoors*, and the award-winning *Extreme Alpinism*, co-authored with Mark Twight. When asked how he's done so much, he replies, "I married well."

John Harlin III

A former Colorado mountain guide, writer John Harlin's early years were spent in Switzerland, where his father climbed and his mother taught science. After his father's death on the Eiger in 1966, the family moved to Washington State, where he first came to know "The Mountain"—a.k.a., Mount Rainier. Following his graduation from the University of California, Santa Barbara, Harlin explored mountain ranges throughout North and South America, and made climbing forays to Tibet and the Alps. "I write about the outdoors because I'm passionate about the world outside," Harlin explains. He was editor at *Summit* magazine, Northwest editor for *Backpacker*, editor of the *American Alpine Journal*, author of *A Climber's Guide to North America* and of *The Eiger Obsession: Facing the Mountain That Killed My Father*, and star of the IMAX movie, *The Alps*, as well as episodes of the PBS television series, *Anyplace Wild*. Harlin recently founded Digital Outdoors Publishing, where he is the editorial director. He lives in Hood River, Oregon.